AROUND BURNHAM

From Old Photographs

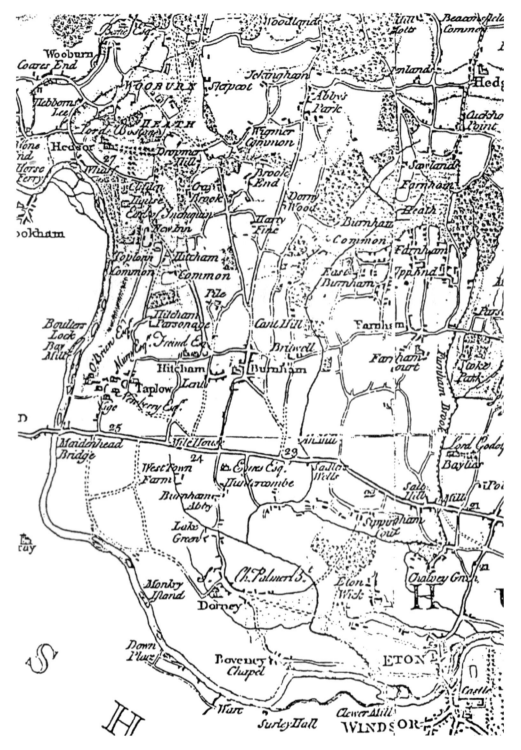

Part of Thomas Jeffrey's map of 1788, showing the area covered by this book.

AROUND BURNHAM

From Old Photographs

DOROTHY BLACKMAN &
DAPHNE CHEVOUS

AMBERLEY

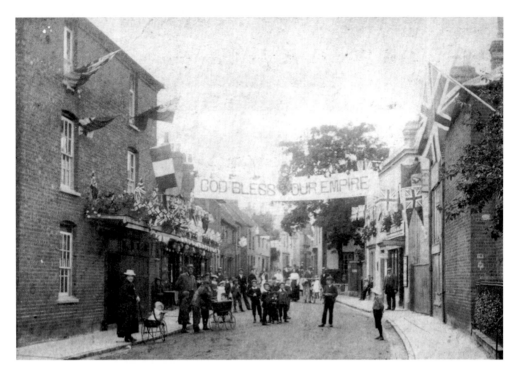

Burnham High Street, *c.* 1910. Local inhabitants are enjoying the shops decorated for Empire Day by shopkeepers Cleares, Lawleys and Hebbes.

First published 1993
This edition published 2009

Copyright © Dorothy Blackman and Daphne Chevous 2009

Amberley Publishing
Cirencester Road, Chalford,
Stroud, Gloucestershire GL6 8PE

www.amberleybooks.com

British Library Cataloguing in Publication Data.
A catalogue record for this book is available from the British Library.

ISBN 978-1-84868-555-0

Typesetting and origination by Amberley Publishing
Printed in Great Britain

CONTENTS

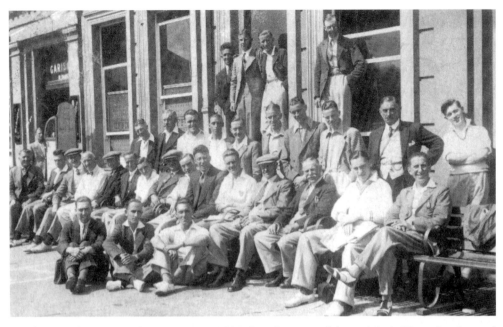

Burnham cricket team and supporters, c. 1925. Standing second from right is Henry Lawley, and seated in front of him is Alf Small. (Other names would be welcomed.)

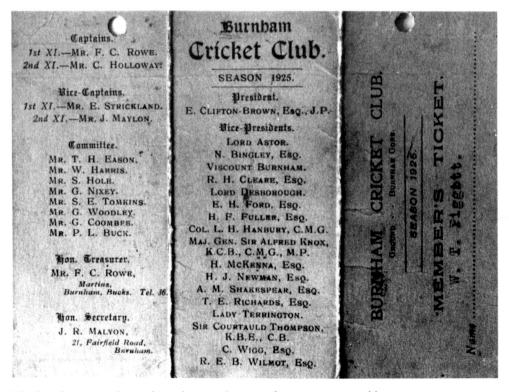

Captains.
1st XI.—Mr. F. C. Rowe.
2nd XI.—Mr. C. Holloway.

Vice-Captains.
1st XI.—Mr. E. Strickland.
2nd XI.—Mr. J. Maylon.

Committee.
Mr. T. H. Eason.
Mr. W. Harris.
Mr. S. Hole.
Mr. G. Nixey.
Mr. S. E. Tomkins.
Mr. G. Woodley.
Mr. G. Coombes.
Mr. P. L. Buck.

Hon. Treasurer.
Mr. F. C. Rowe,
Martins,
Burnham, Bucks. Tel. 36.

Hon. Secretary.
J. R. Malyon,
21, Fairfield Road,
Burnham.

**Burnham
Cricket Club.**

SEASON 1925.

President.
E. Clifton-Brown, Esq., J.P.

Vice-Presidents.
Lord Astor.
N. Bingley, Esq.
Viscount Burnham.
R. H. Cleare, Esq.
Lord Desborough.
E. H. Ford, Esq.
H. F. Fuller, Esq.
Col. L. H. Hanbury, C.M.G.
Maj. Gen. Sir Alfred Knox,
K.C.B., C.M.G., M.P.
H. McKenna, Esq.
H. J. Newman, Esq.
A. M. Shakespear, Esq.
T. E. Richards, Esq.
Lady Terrington.
Sir Courtauld Thompson,
K.B.E., C.B.
C. Wigg, Esq.
R. E. B. Wilmot, Esq.

BURNHAM CRICKET CLUB.
Ground ... Burnham Gore
SEASON 1925

MEMBER'S TICKET.
W. E. Piggott.
Name

The list of vice-presidents of Burnham cricket team features some notable names.

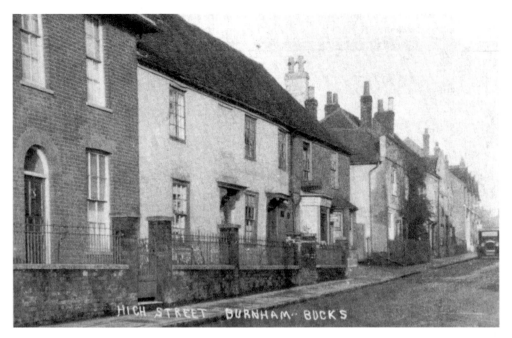

The left-hand side of the High Street, looking north, in the 1920s, showing the Misses Deverills' school with its Georgian frontage and creeper.

INTRODUCTION

Since the publication of *Yesterday's Town: Burnham*, many people have delved into their family archives and offered further photographs, which has made a second selection possible. This volume provides views of Burnham's surrounding villages, and shows the people at work and play.

Burnham was always a farming area, comprising land belonging to the gentry who employed local people as labourers and gave leases to tenant farmers, common land, on which villagers were allowed to graze their livestock, and the village itself, centred around the High Street.

When the railway was built in 1838 the population was 2,094 (which was greater than Slough or Maidenhead). Tradesmen were attracted to the area, and within a hundred years the population had doubled. In the nineteenth century Burnham boasted two iron foundries, a brewery, a printing works, two laundries and a long-standing fire service. The High Street was well supplied with shoe shops, several grocers, butchers, bakers and its own chemist and post office. A number of these shops have survived to form part of today's busy High Street in one of the largest villages in the country. Many and various sports were supported and patronized by the local gentry and tradesmen, and a strong community spirit was developed, which prevails today.

Links with the surrounding area were, and in some cases still are, strong. Lent Rise,

formerly a small hamlet at Lent Green, has continued to expand and has become a thriving community; Britwell, now largely a housing estate, was once all part of Burnham's farmland; Cippenham, when it consisted mainly of farms and was still a small community living around its pond, used to be part of Burnham. Part of the parish of Dorney may be found within Burnham, on the edge of the Beeches. The manor house, Dorney Court, is still owned by the Palmers, as it has been for the past three hundred years. The Grenfells lived at Taplow Court, while Cliveden House was the home for many years of Nancy Astor. A former Prime Minister, Lord Grenville, built Dropmore House and made his permanent mark on the area, as did George Hanbury and his family, who built Blythewood at Hitcham.

East Burnham, Farnham and Hedgerley border on the beautiful Burnham Beeches. In 1879 the Dropmore Estate, including Burnham Beeches, was put up for sale in lots. The Beeches were saved by the efforts of Francis Heath, with the assistance of Sir Henry Peek, MP, who bought the 574 acres and resold 374 acres to the Corporation of London to be preserved for the permanent enjoyment of the public. The parishes of Burnham, Hitcham, Dropmore and Taplow are now all part of the Burnham Team Ministry, which helps to foster a neighbourly relationship between the villages.

The following pages are a nostalgic tour of the area, illustrating the changes of the past century that have made Burnham and its environs what they are today.

 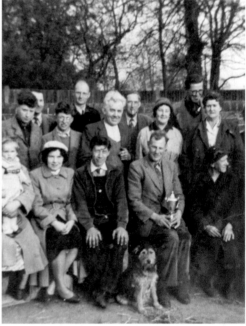

Priory Farm, also known as Lobjoit's Farm, occupied the land that is now Burnham Upper School playing-field. The farmhouse (left) stood in Stomp Road, opposite the entrance to The Priory. The owner in 1952 was Mr Speakman (right), seen holding the trophy for the best potato crop in South Bucks. The house was demolished in 1964 before the school was built.

Burnham Village

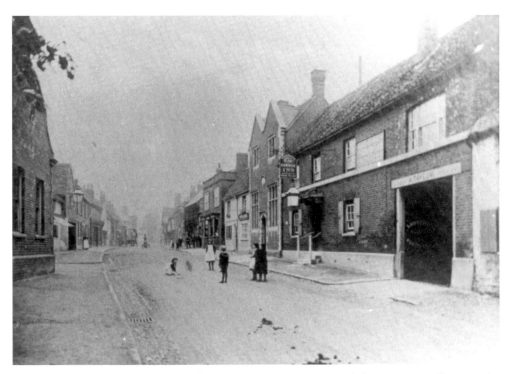

Burnham High Street, early twentieth century. The George Inn and the Mission Hall are on the right, the fire station (when it was a single-storey building) is on the left. Children were able to play safely in the road then.

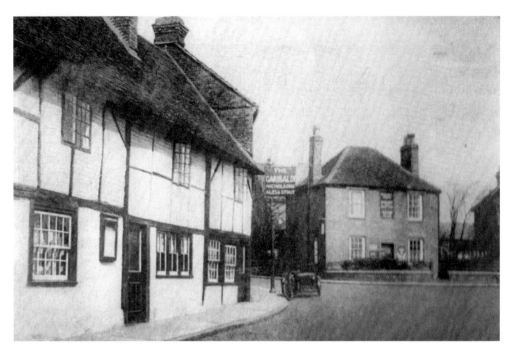

The Garibaldi, early 1900s. Before it was licensed, in 1858, this public house had been three Tudor cottages. Across the road is South End House, which was an estate agents at the time, the front door facing south.

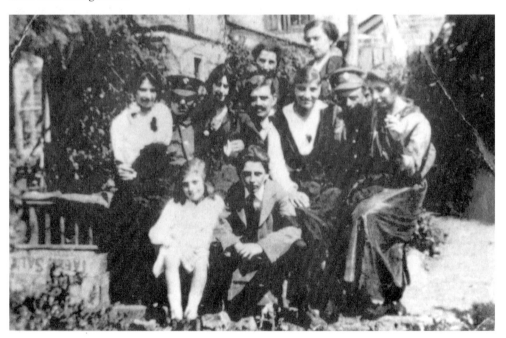

A touching scene, captured often during the First World War. The Knight family, who ran The Old Feathers in the High Street, are in their garden with friends on leave from the army.

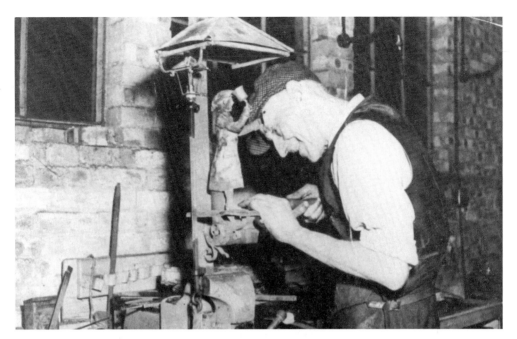

Arthur Stone, the blacksmith, worked in the iron foundry behind the present Ashley George's. He is making an elaborate door knocker in the shape of a town crier. Arthur also made the beautiful wrought iron entrance gate at St Mary's church, Hitcham.

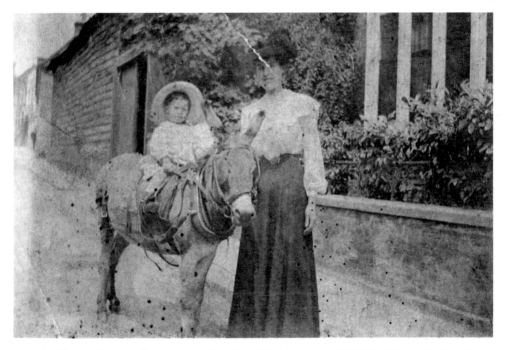

Outside Cleares' Farm at the bottom of Burnham High Street, *c.* 1905. The Harris family, who ran a laundry in Gore Road, owned the donkey, which helped to deliver laundry to their customers.

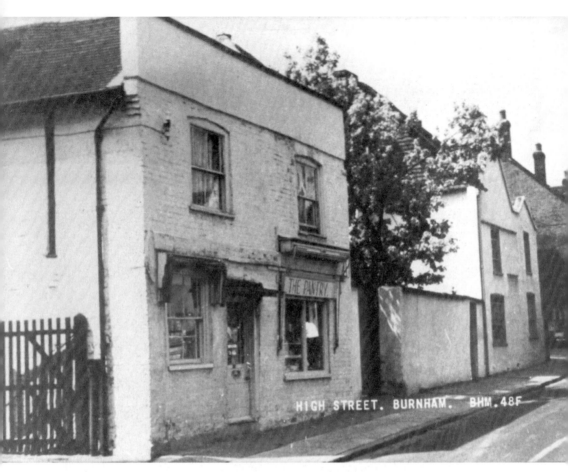

The Pantry was the village cooked-meat shop in the 1930s and '40s, and is still known by this name among older villagers. In the early years of the twentieth century it was a private school for boarders and day pupils run by the Deverill family. The present owners discovered that the flat Georgian frontage hides two adjoining Tudor cottages. It is now 27 High Street.

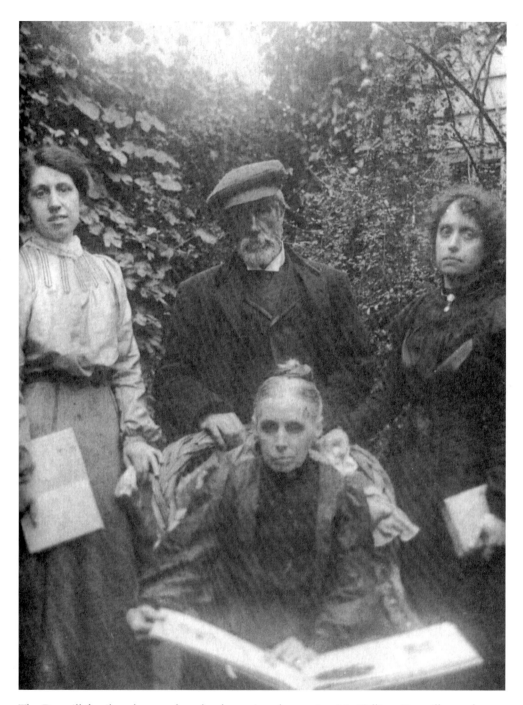

The Deverill family, who ran the school mentioned opposite. Mr William Deverill was the son of John Deverill, who started a building business in Slough. William is seen here with his wife, Harriet, who founded the school, and their two daughters. Jessie was a clever artist and Eva a fine pianist. They took over the school on their mother's death in 1910.

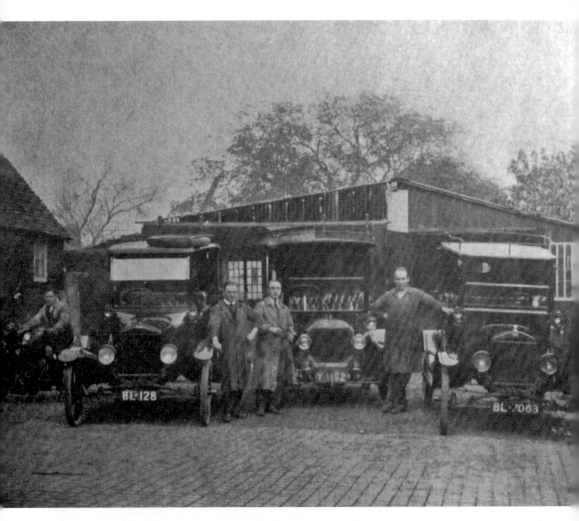

Strickland's Garage behind The George Inn, 1920s. Left to right: Bobo Penny (on the motor bike), Tommy Lechmere (former chauffeur to Edward Clifton-Brown), Len Phelps, Bob Ashley and Gordon Strickland (the owner, and uncle of Bobo).

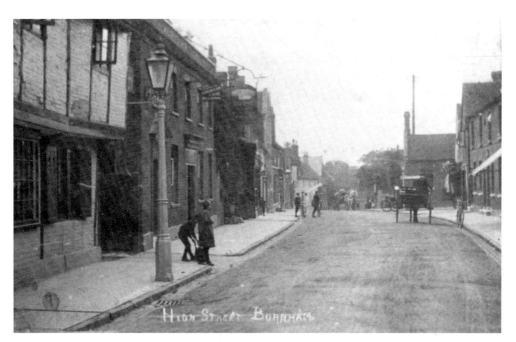

The south-eastern part of Burnham High Street. Swan Cottage and The Swan Hotel are on the left, and the only form of transport, as far as the eye can see, is the horse and cart.

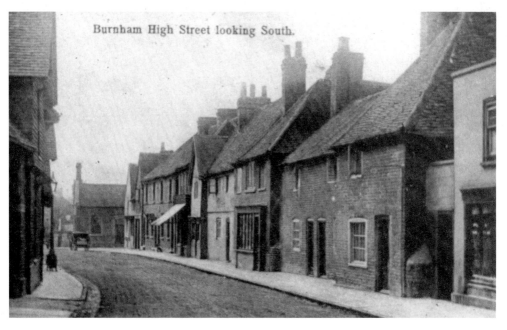

The south-western side of the High Street at around the same time as above. The old cottages (right) were demolished to make way for Whiteley's clothing store, later the International Stores and now the National Westminster Bank. In the distance is the old fire station (when it was a single-storey building).

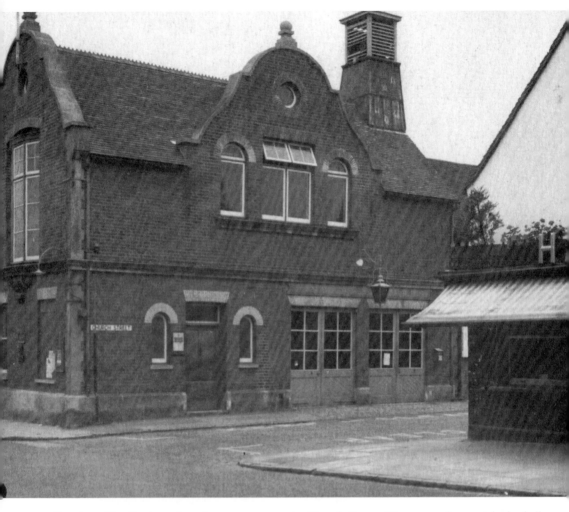

Burnham Fire Station when the entrance was in Church Street. The room above with the bell tower, built in 1908, served as the Parish Council Chamber and housed the lending library, run by volunteers on Tuesdays and Saturdays.

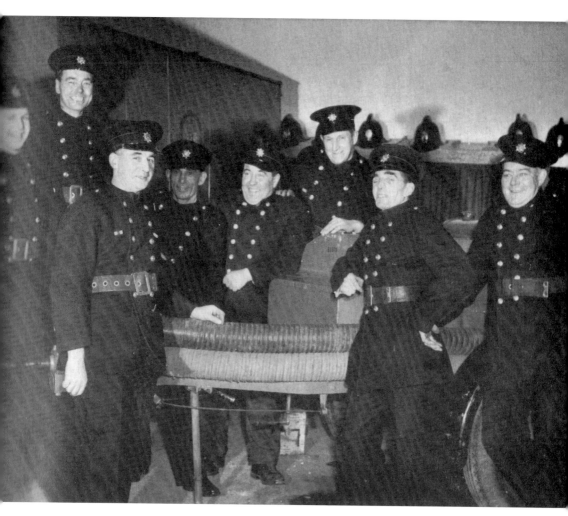

Inside the fire station, 1955. Enjoying a joke are, left to right: Alistair Summers, Reg Haycock, Charlie Bunce, John Parker, Bob Lawley, Ted Bench, Ron Alder and Fred Cock. The firemen's helmets are hung along the end wall.

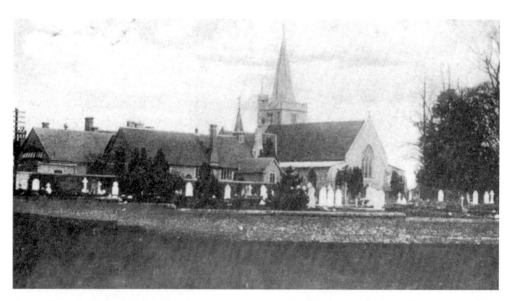

From Cleares' field beyond the wall of the north churchyard the rear of the Church of England school can be seen beside St Peter's church. The school was built in 1871 and served the village until 1971, when the lease expired. It was then demolished and replaced by new schools in Minniecroft Road.

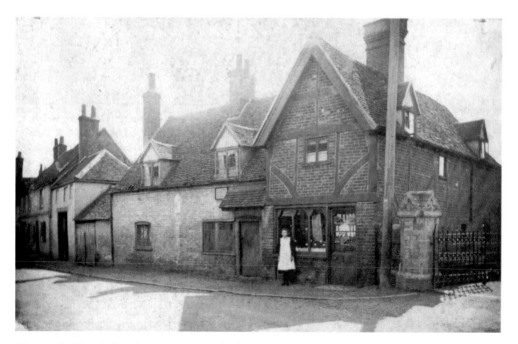

The south side of Church Street, 1900. The house on the right (now Tudor Cottage) was a shoe shop at this time.

On the north side of Church Street stood the sixteenth-century Market House (above left), thought to have been built on the original site of Burnham Market.

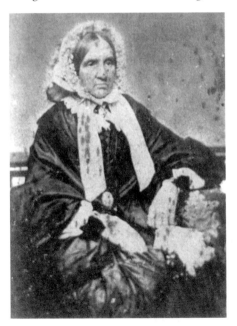
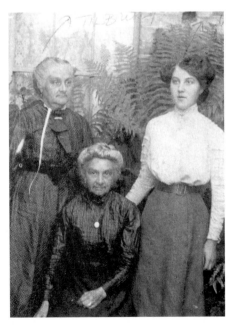

The Tilbury family lived for many years in what is now Tudor Cottages, Church Street. Three generations were shoemakers. Bottom left: Mrs Tilbury, born in around 1800; top right: her son, John, the first shoemaker; bottom right: the wife of his son Jim (the parish clerk), with her sister and daughter.

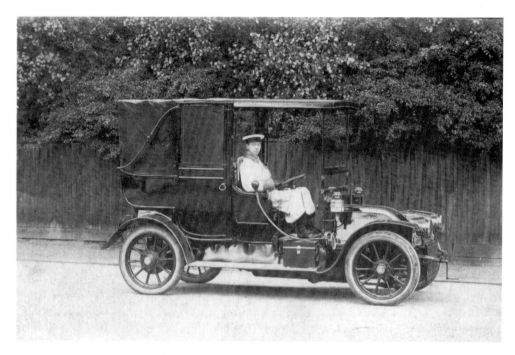

Jim Tilbury's son (above) in chauffeur's uniform, driving an early motor car, and (below) later at the wheel of a Sunbeam.

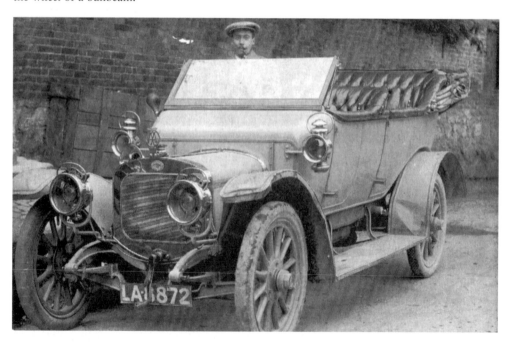

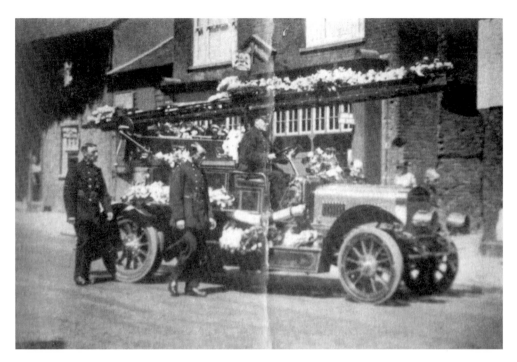

The funeral of the captain of the fire brigade, 1938. Harry Baldwin, who followed his father in their iron foundry, was captain of Burnham's fire brigade for forty-one years until his death.

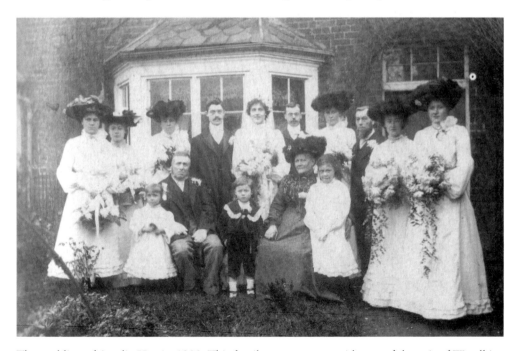

The wedding of Amelia Harris, 1908. This family group was outside one of the pair of Woodbine Cottages, which stood where Jennery Lane joins Burnham High Street.

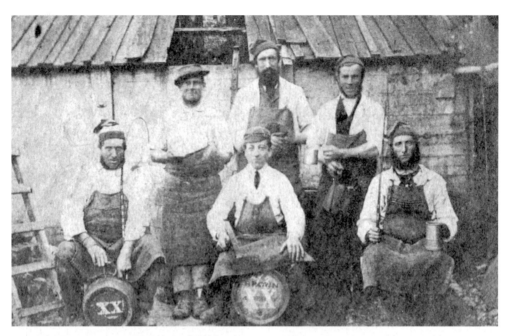

Charles Harris and his brother worked at the Rose Brewery (behind which Sands Garage now stands) from 1864 to 1883. They are pictured left and right front, with their colleagues and the tools of their trade.

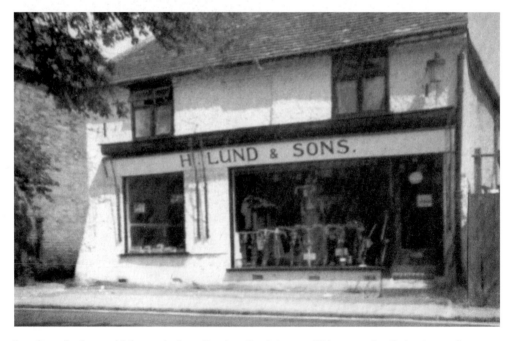

Lund's cycle shop, which stood where Barclays Bank is now. This was a family business where you could buy a super new bicycle or a reliable secondhand one, or even get your wireless accumulator charged.

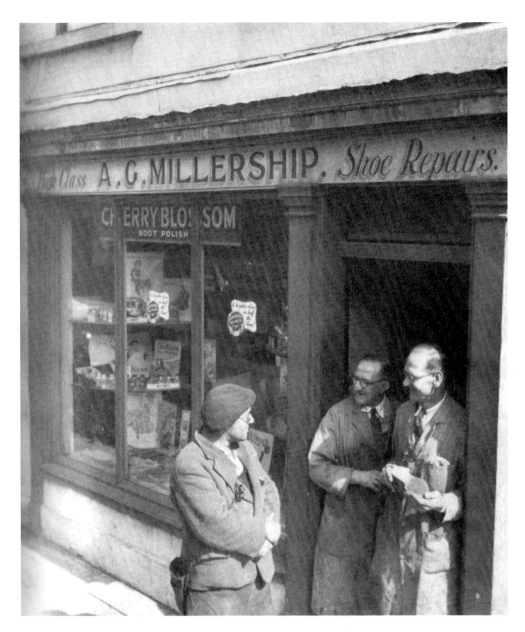

Alf Millership and his brother Ernie in the doorway of their shop where Budgen's stands now. They started business in Lent Green in the 1920s and continued together until 1957. Two of life's gentlemen, they made new shoes from old and are seen talking to another well-known character, Mr Webb, the coalman. Ernie Masters and his brother, Cyril, took over the friendly family firm and moved farther down the High Street, where they carried on the business until 1992.

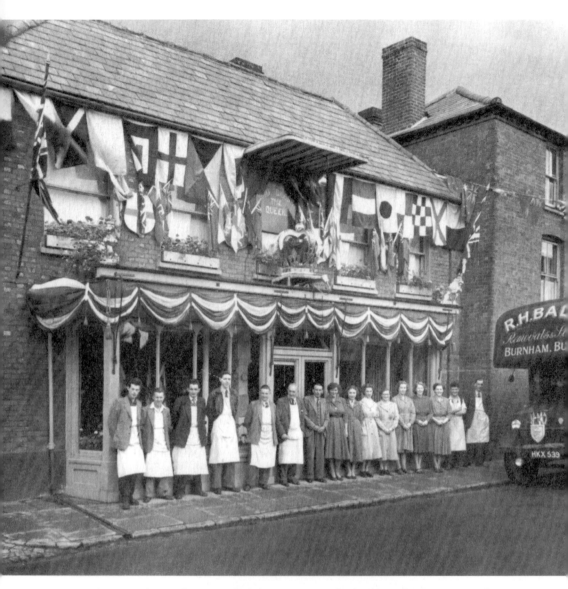

R.H. Balm started as a furniture dealer, in 1928, in the building the company still occupies. Pictured here are the staff and the delivery vehicles. Left to right: Harold Witney, Vic Smith, Jack Hayman, Frank King, William Oaks, Arthur Thrift, Mr Jack Balm, Mrs Dora Balm, Ann Hawes, Vera Knight, Rhona Knight, Doreen Strafford, Joan Prince, Betty Prince, Ron Fox and Ron Newell. The occasion was Queen Elizabeth II's coronation in 1953.

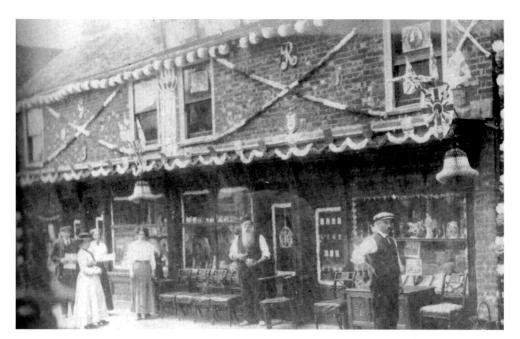

Old Robert Lawley (centre) and his family, outside their antique shop in the High Street, 1911. The shop was decorated for the coronation of George V.

POSTAL INFORMATION.

INLAND POST.
 Letters—Weight not
 exceeding 2 ozs. ... 1½d.
 Printed Papers, 2 ozs. ... ½d.

INLAND TELEGRAMS.
 12 words, 1s.; every additional
 word, 1d.

REGISTERED NEWS-PAPERS.—6 ozs. 1d. and ½d.
 for each 6 ozs. after. (Limit
 2lb.).

POSTAL ORDERS.—6d. to
 2s. 6d., fee 1d. 3s. to 15s.,
 fee 1½d. 15s. 6d. to 21s.,
 fee 2d.

POSTCARDS, 1d.

**FOREIGN AND COLONIAL
 LETTERS.**— British
 Possessions generally
 and U.S.A., 1 oz. ... 1½d.

PARCEL POST.

1 lb.	0s. 6d.	7 lb.	1s. 0d.
2 lb.	0s. 6d.	8 lb.	1s. 0d.
3 lb.	0s. 9d.	9 lb.	1s. 3d.
4 lb.	0s. 9d.	10 lb.	1s. 3d.
5 lb.	0s. 9d.	11 lb.	1s. 3d.
6 lb.	1s. 0d.		

(Limit 3ft. 6s. long, or 6ft. length
 and girth combined).

Postal rates in the 1930s, when telegrams could bring good and bad news, and even very large parcels could be delivered for a small sum.

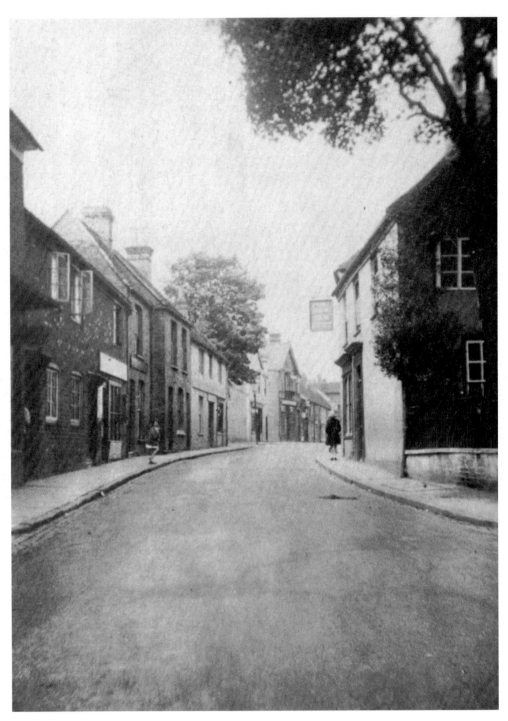

Few people will remember this view of the High Street. On the right is the maple tree in Lawley's garden with The New Inn beyond (now the hairdressers). The old cottages (left), Bennett's bakers and Sarson's grocers were all demolished to make way for the new row of recessed shops.

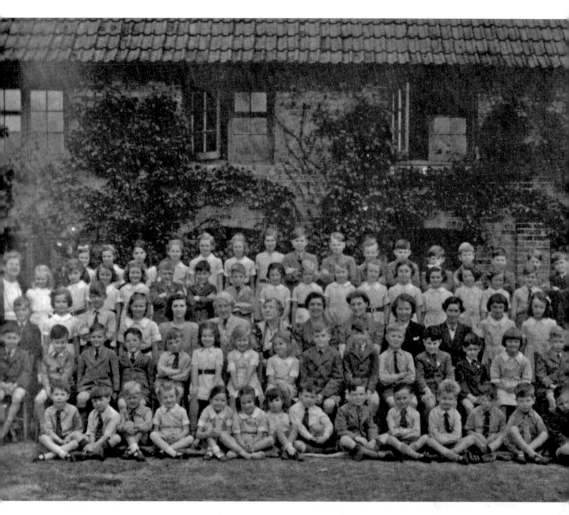

The grounds of Reedham House School in Britwell Road backed on to the Malt House in the High Street. Here, in around 1944 the schoolchildren and staff pose at the rear of the Malt House (almost identical to the front in the High Street, now Robinson's). At that time mentholatum was tinned in the Malt House. The schoolteachers include Mrs E. Bayley (headmistress), Mrs Fuller, Miss Rose and Mrs Townsend.

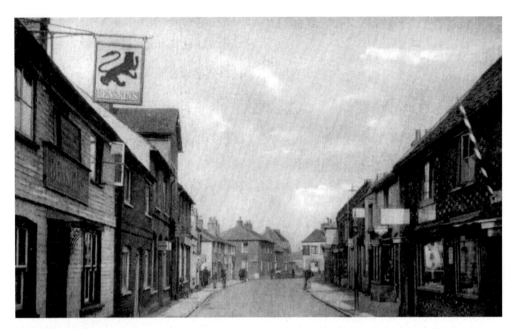

In 1940 The Red Lion (left) was demolished and rebuilt further back, in its present position. In the distance (centre) is Cleares' House, the first purpose-built telephone exchange (next) and The Alma public house (beyond), all now gone. On the right is the striped pole, the sign of a barbers, with Mr Percy's sweet shop next door.

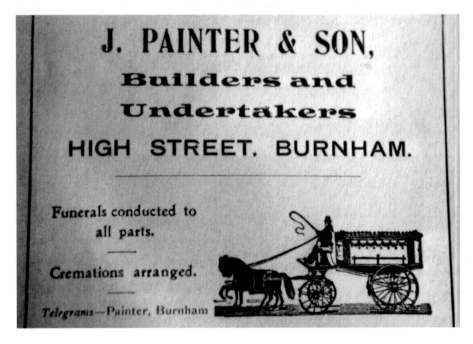

A 1920s advertisement, with a reminder of the glass carriages and plumed horses used for funerals in those days.

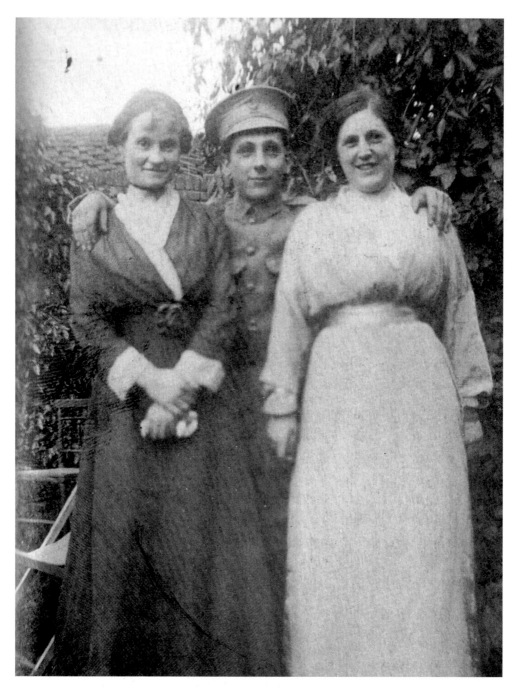

Private James Herbert Painter, with his mother and sister, 1916. His family came to Burnham in 1830 and followed various trades. Herbert, known as 'Bert', had volunteered to become a private in the Oxford & Bucks Light Infantry, as did so many young men from the village. He returned to take up the reins of the family builders and undertakers business for the rest of his life, the premises of which are now occupied by The Shepherd Press.

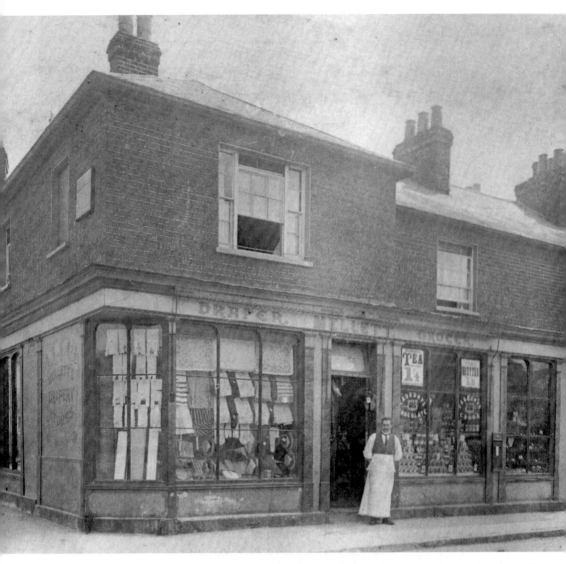

This drapers and grocers, established by Thomas Mellett in 1853, is pictured just as the Collett family took it over in 1908. The man at the door is Mr Harris, who later started his own grocers further down the High Street.

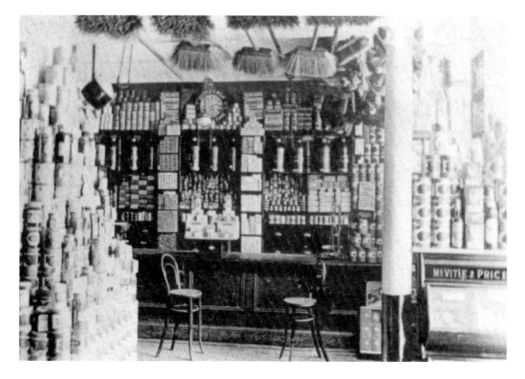

When we say that you obtain

GOOD QUALITY
GOOD VALUE
GOOD SERVICE

at COLLETTS STORES, that is

PERSPICUITY

When you send your kind orders for
GROCERIES and PROVISIONS to the
old established and reliable firm of
COLLETTS STORES that is

PERSPICACITY

Tel. BURNHAM 27.

A delightfully worded advertisement and a view of the inside of this old-fashioned family store, which was like Aladdin's cave.

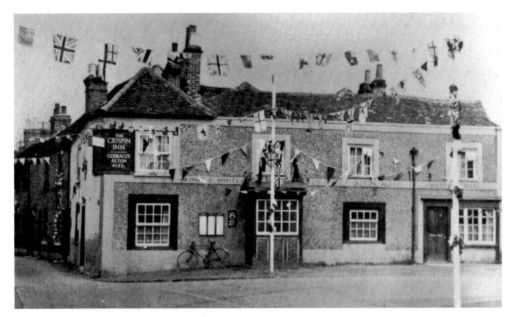

The Crispin Inn at the top of Burnham High Street, which had been decorated for the coronation of George VI. The terraced cottages (left) in North End (formerly Bustle Row) have now made way for Alma Court.

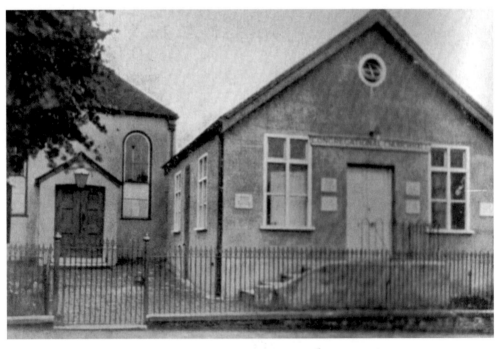

The Congregational church in Gore Road was built in 1791 and was known as Zion chapel. The new church hall (right) was built in 1928 on the original graveyard to provide school and committee rooms.

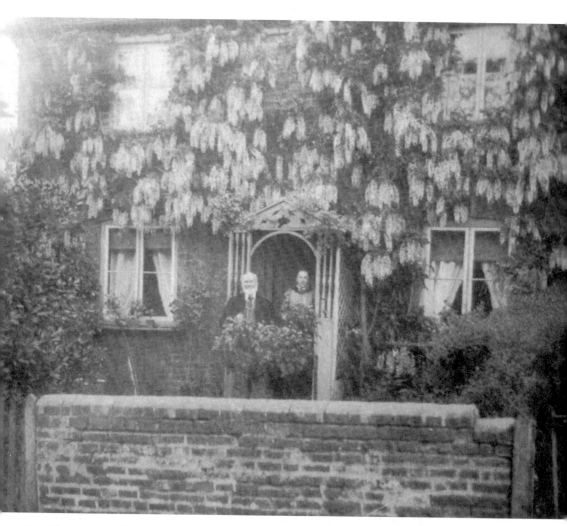

Bay Tree Cottage, Gore Road, where Bay Tree Court is now. Mr and Mrs William Bennett are at the door, proud of the wisteria in bloom. William and his family were bakers in the village from 1847 until around 1939.

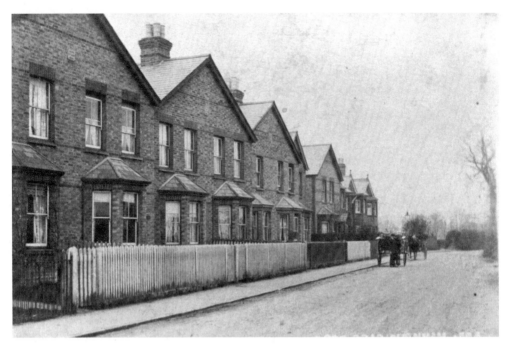

Gore Road in the early 1900s, when this row of recently built cottages stopped opposite Tockley Road.

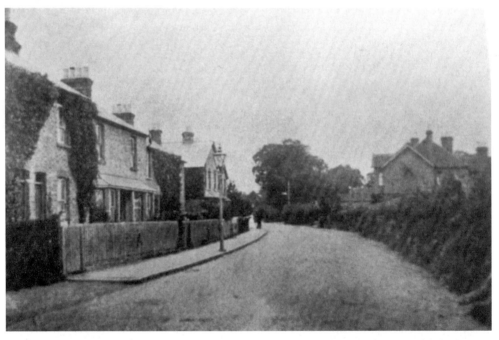

Gore Road a little further east, showing the house (right) that was Harris's (later Dawe's) laundry, now Lipscombe's MOT service. In the 1920s and '30s Bradley's laundry stood near the site of the present Minniecroft Road.

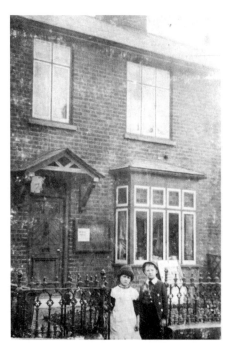

This boy and girl (above) were the children of William Hyde, who started his printing business in this house in Britwell Road in around 1890. The son, Irby Hyde, took over in 1915 when the company had expanded into the printing works just along the road. Ambrose and Joseph Hyde were builders, while Reginald was in insurance. The advertisement (below) dates from 1920.

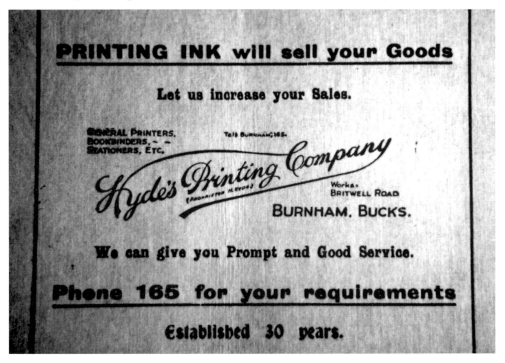

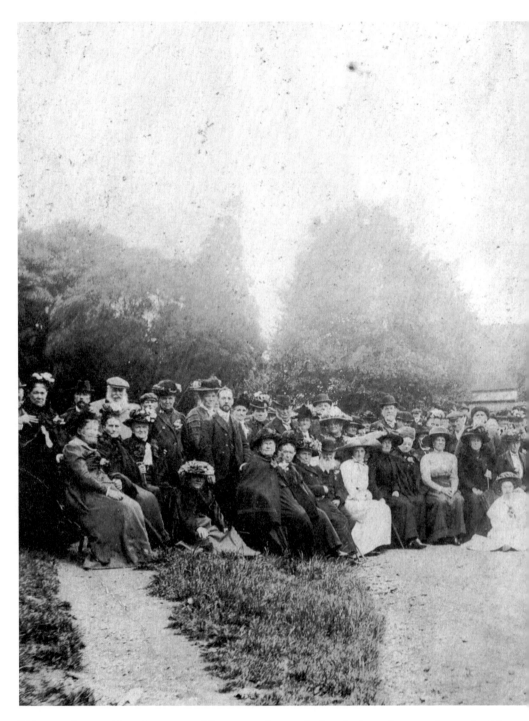

This scene is something of a mystery. The group of around a hundred people are at the south of St Peter's church, where later the war memorial was built. Some are wearing flowers either in their hats or buttonholes – perhaps they were members of The Primrose League.

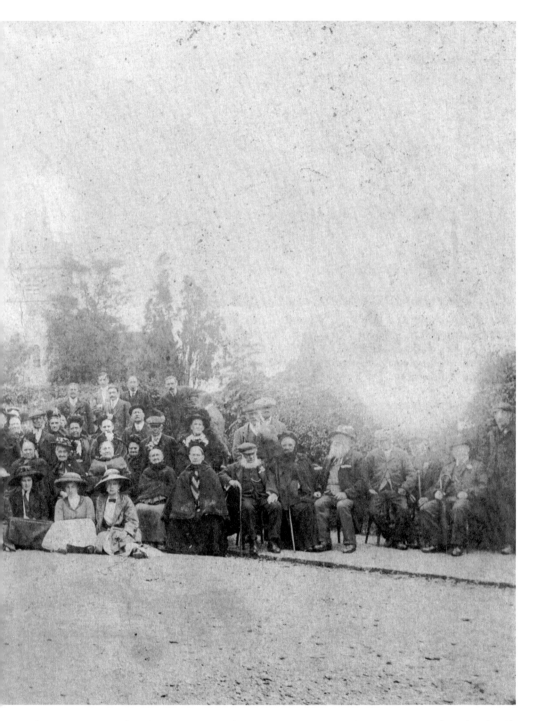

The picture was taken by an amateur photographer sometime between 1891, when the church spire was built, and 1920, when the war memorial was erected.

These shops (above and below) in Windsor Lane (now Burnham Lane) were part of a gradual development between 1903, when Burnham Beeches station was built, and the growth of the trading estate in the 1920s. They served the rapidly growing housing estates nearby. Windsor Lane continued to the edge of the trading estate, where Haymill House and pond stood.

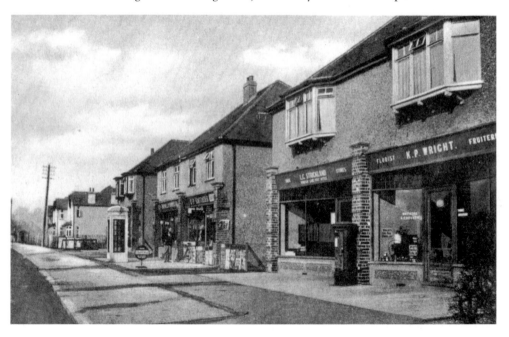

SECTION TWO
Lent Rise

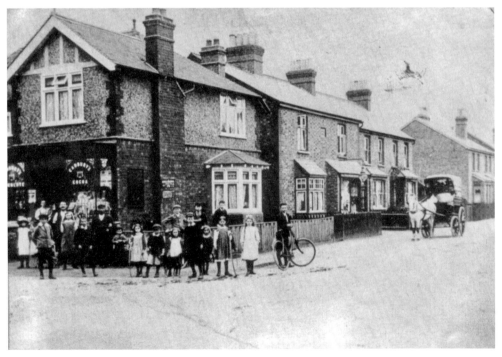

Local children outside the grocery store at the corner of Milner Road, *c.* 1912. Next door, with the delivery cart outside, was Miss Glading's Fancy Repository.

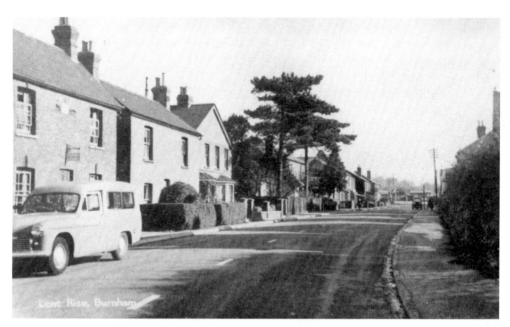

Eastfield Road, looking towards Cornell's Corner, *c.* 1950. Beyond the trees (left) is Milner Road, with Lent Rise post office, formerly Hardings' Coal Office, on the corner. The Hardings also ran the grocers here until the early 1970s. Plevey's butchers can just be seen at the far end of the road.

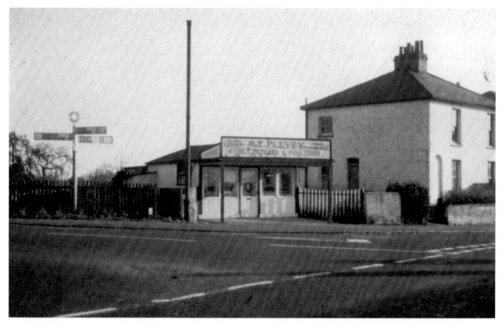

Plevey's moved from their shop in Lent Rise Road to this wooden building in around 1930. It served the local community through the Second World War and continued until the early 1970s, when it was demolished, along with the cottages next door, to make way for Lent Rise School.

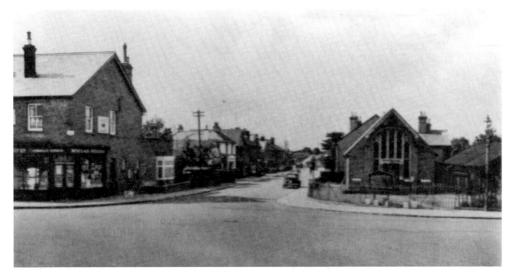

Cornell's grocers was the corner shop (left) when the first buses ran, and it is still included on the local timetable. The Methodist church (right) was built in 1895 to accommodate a growing congregation.

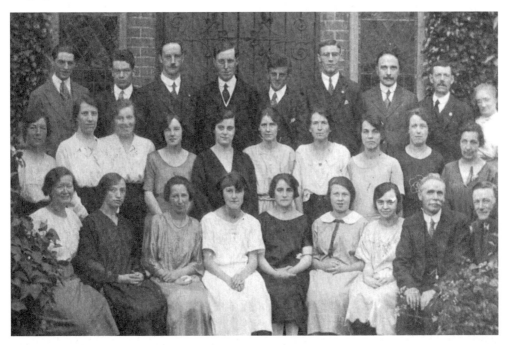

One of the Methodist church's most ardent supporters was Frederick Moon (front row, second from right), the conductor of the choir. He also ran the local dairy, later a newsagents. Next but one to him is his daughter, Olive. Connie Williams, the pianist, whose family kept the bakers in Eastfield Road, is third from the left (same row). This flourishing choir won the local Methodist churches' Eisteddfod in the 1920s.

Barr's Nurseries occupied the site of the present Nursey Estate, built in the late 1950s at the end of Lent Rise Road. Between the wars a number of market gardens flourished in the Burnham area. The tithe map of 1842 shows a gravel pit here. The grass verge where Harold Tripp and his son are sitting was a favourite resting place in the 1930s.

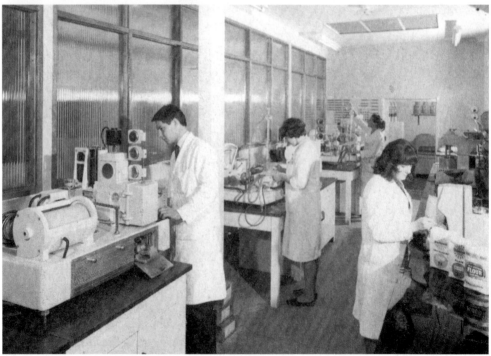

Flour testing at Weston's Laboratories. The clock belonging to the laboratories, at the corner of Lent Rise and the Bath road, was a local landmark.

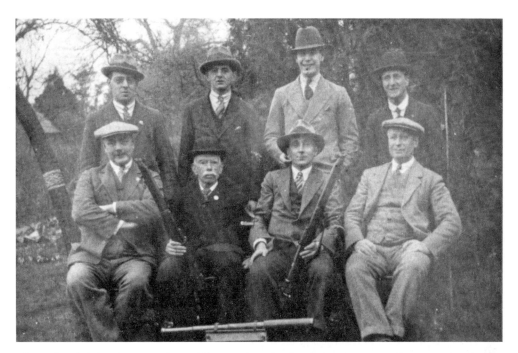

The Rifle Club has been sited in Aldbourne Road since the early twentieth century. Back row, left to right: Arthur Lloyd, Fred Lloyd, -?-, Vic Trimming. Front row: -?-, -?-, Bert Painter, Harry Wood. In the 1920s some members of the Rifle Club formed the Burnham Bowls Club.

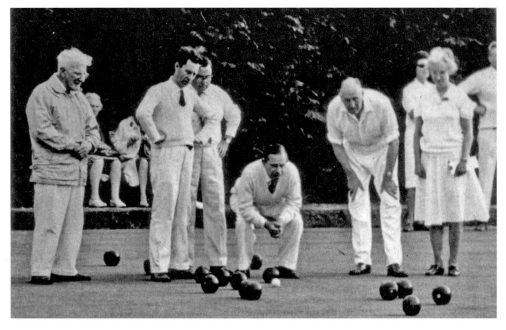

Far left is Vic Trimming who still played bowls in his late eighties. His family started the first garage at Lent Rise, with cars for hire, in 1920.

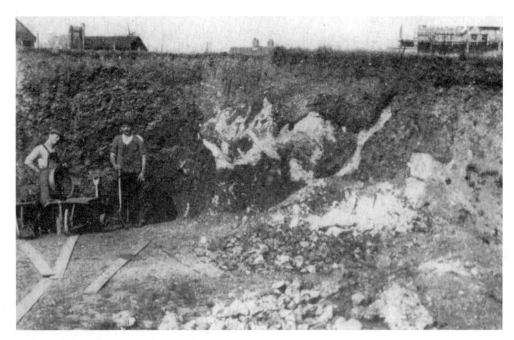

At the end of the nineteenth century the brickfields north and south of Stomp Road were owned by George Wethered of Maidenhead. In 1912 he was listed as the manager of the Burnham and Marlow Brick Co., which worked the Chiltern Road site until extraction was completed in 1930.

Two members of the Carter family at Dewstraw Cottage (now 137 Lent Rise Road). Before this and other, adjacent houses were built the land was farmed in strips stretching back beyond Milner Road, which was built in the 1890s.

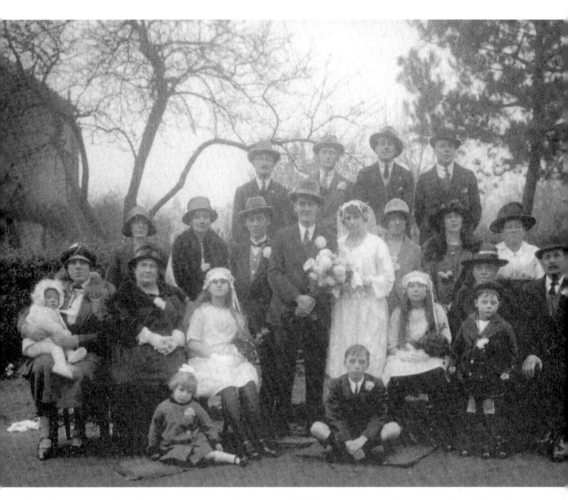

On the occasion of their daughter's wedding, in the 1920s, Mr and Mrs Carter and their family gathered in the road just beyond Dewstraw, unhindered by traffic, for a group photograph. The bridesmaids' muslin caps and their black stockings under their white dresses are typical of the weddings of this period, as are the men's trilbies, the 'pot' hats of the ladies and the sailor's hat on the small boy.

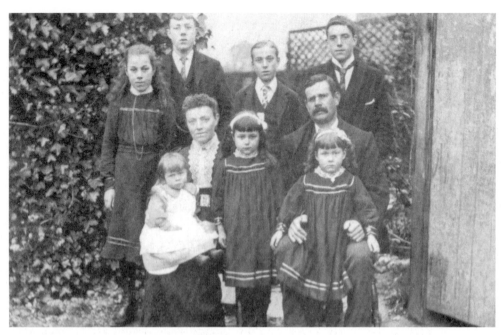

Fred Carter and his family in the garden of Dewstraw Cottage, early twentieth century. For forty-nine years Fred worked at the brickfields in Stomp Road, and was a bellringer at St Peter's church.

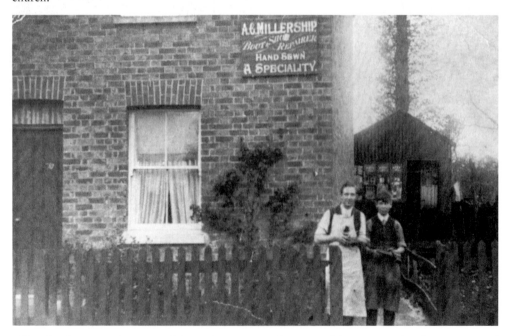

Alf Millership, recently returned from the First World War, and his younger brother, Ernest. Alf started his shoe repairer's business in an ex-army shed behind his house at Lent Green. He and Ernest later took over the premises of Webster's Corn Merchants in the High Street.

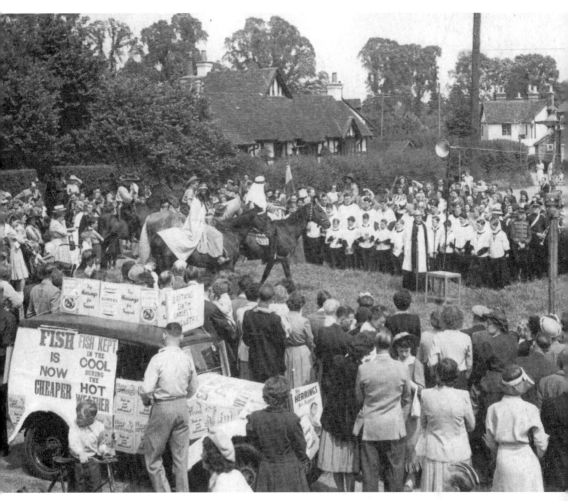

Service at Lent Green, early 1950s. This was the culmination of the annual Bells' Parade to raise money for refurbishing and rehanging the bells after the Second World War. Dr Maxwell Summers is leading the parade on horseback. The service is conducted by the Revd James Wildman.

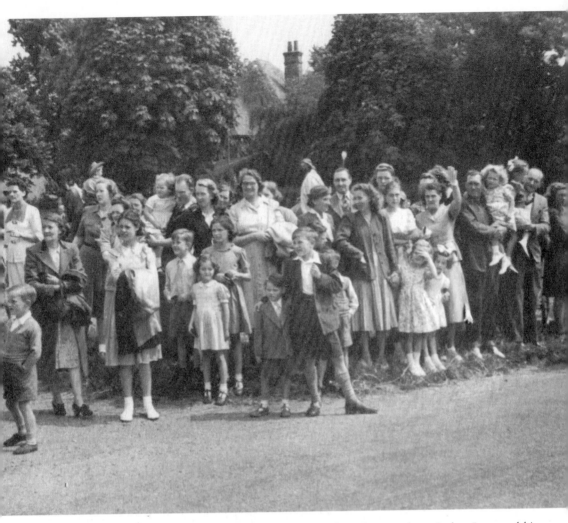

Watching the Bells' Parade at the top of Lent Rise Road. In the crowd are Arthur Laye and his daughter Carol, Mr Boweren, Mrs New, Doreen Strafford, and members of the Lane and Carter families.

Dorney
and Taplow

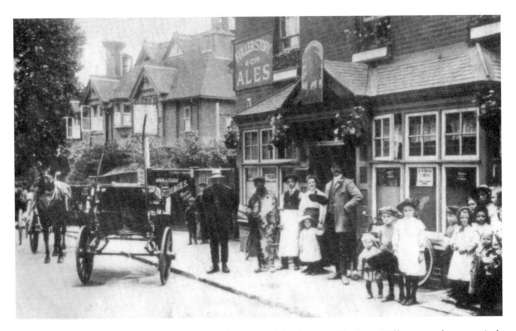

Villagers gathered outside The Oak and Saw public house, Taplow Village, early twentieth century. As well as the delivery carts in the foreground, an errand boy's bike is leaning against the window. A notice in the window of the pub advertises teas.

Station Road, Taplow. Like most stations, that of Taplow was well outside the village. Opened in 1872 it replaced the original Maidenhead (Riverside) station. It was built mainly for the convenience of weekend guests visiting Taplow Court and Cliveden, including the Prince of Wales, later Edward VII.

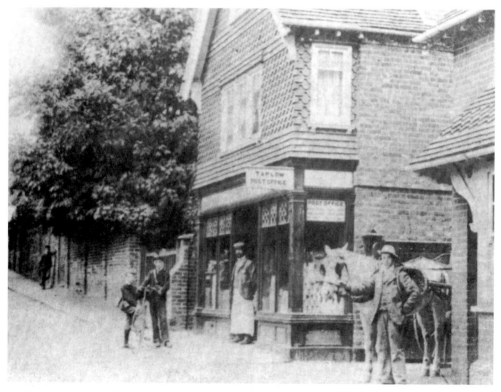

Taplow post office, High Street (opposite the old school), 1890s. It later became Budgen's and then an antique shop.

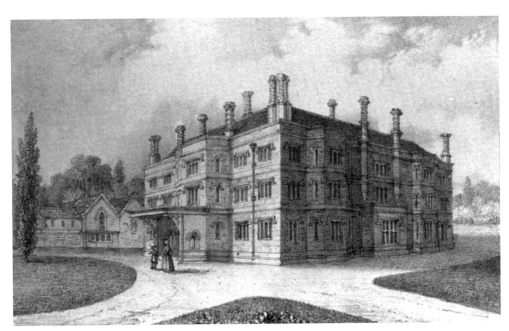

Taplow Court depicted in an eighteenth-century engraving. This was the home of the Grenfells, later Lord and Lady Desborough. They left Taplow after two of their sons, one of whom was the poet Stephen Grenfell, were killed in the First World War. The house was later occupied by the firm of Plessey and now belongs to the Nichiren Shoshu Buddhists.

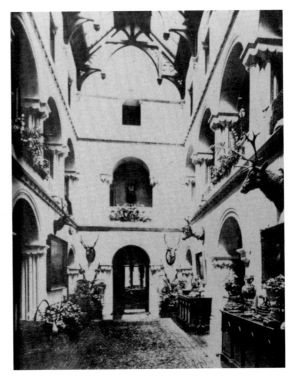

The central hall of Taplow Court in the time of the Grenfells, complete with stag's head trophies. After falling into disrepair the building was refurbished by the present occupiers, thus regaining its period flavour.

A class at Taplow School, 1890s. In the nineteenth century Taplow was still a small rural community. Many of the children would have gone into service in the big houses around the village or worked on the neighbouring farms.

A class at Taplow School, early twentieth century.

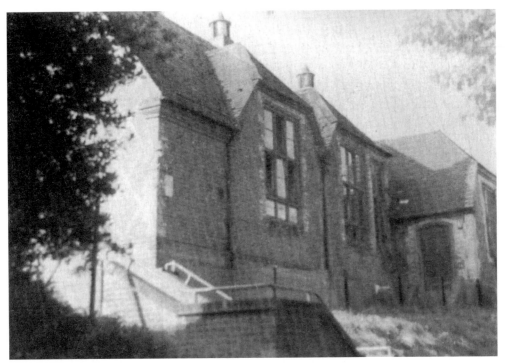

A school existed in Taplow from 1848. The building shown here was erected in 1873 and replaced in 1964. The steps now lead up to the village hall and car park.

Class at Taplow School, 1930s.

Taplow Church of England School relay teams, 1923. The headmaster, Mr Gomm, is in the centre. First team (sitting), left to right: L. Hooper, S. Rush, G. Nicholls, I. Paxton. Second team (standing): A. Sheffield, J. Horsham, R. White, R. Webber.

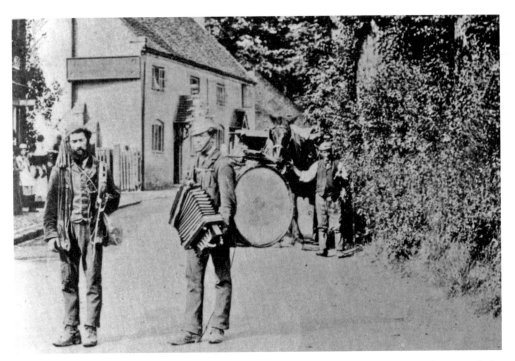

A German band in Taplow, outside The Oak and Saw. This was a common sight around the villages at the end of the nineteenth century.

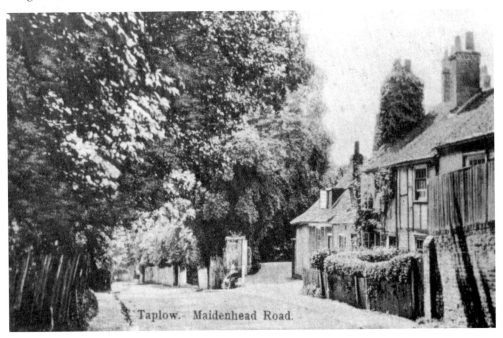

Maidenhead Road, Taplow (now Berry Hill), looking south. The group of houses (right) has been replaced by a new housing complex called Stockwells.

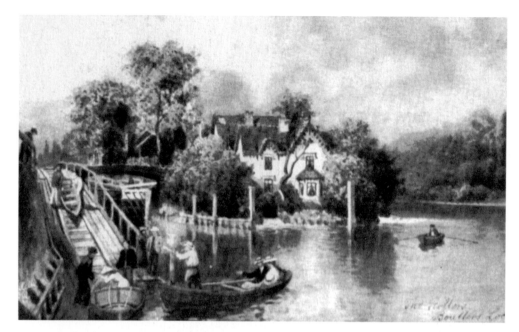

Ray Mill Island at Cliveden Reach in Edwardian times. Owing to the increase in pleasure traffic, rollers had been installed to cut down the waiting time at the lock. Small boats were moved over them to the other end of the lock. The rollers were replaced in 1912 by an electric escalator, the remains of which can be seen behind the old mill house. The fashionable world came to the river at this time, and Skindle's Hotel was a popular venue for 'bright young things'.

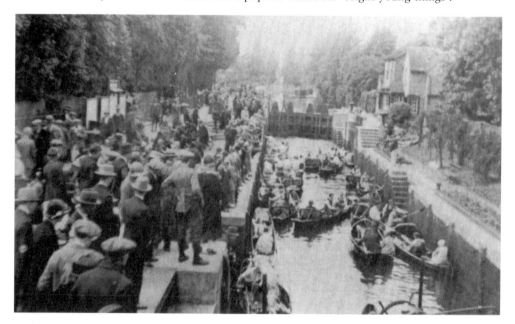

In the 1920s Sunday afternoon's entertainment for the less well-off was watching the boats at Boulter's Lock.

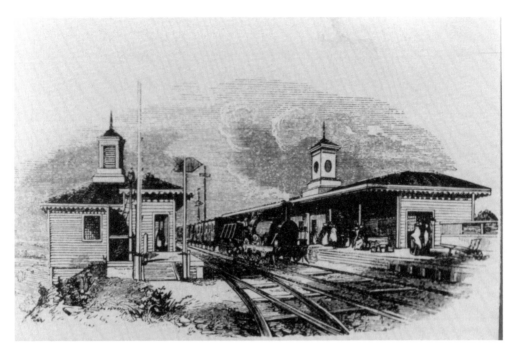

Maidenhead (Riverside) station on the embankment above the present Old Station Inn at Taplow. This station served Taplow and Maidenhead from 1838 until 1872, when the present Taplow and Maidenhead stations were built. The engine on the 7 ft broadgauge line is pulling a stagecoach loaded onto the first truck.

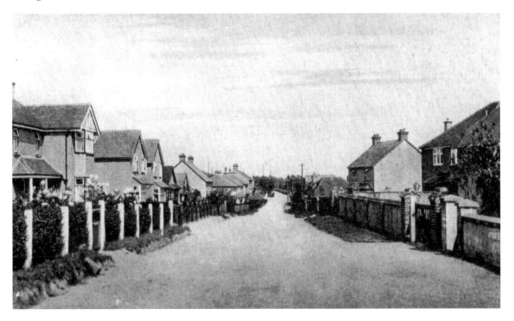

Station Estate, Taplow, was built around the present Taplow Road in the 1920s, when rail travel was more popular than the motor car.

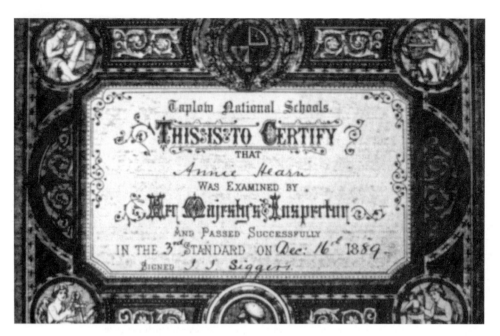

In the 1880s and '90s pupils had to pass a yearly examination to move up to the next standard, or class. National Schools were run by the Church; those set up by the State were called Board Schools and were run by a board of managers.

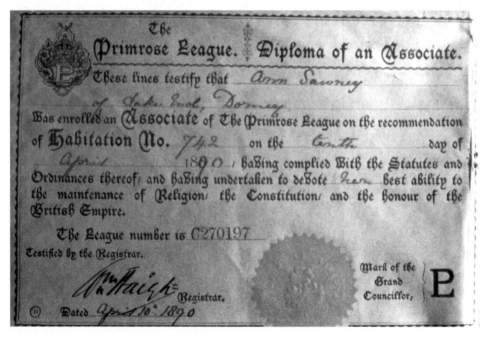

The Primrose League was a Conservative association started in 1883 in memory of Lord Beaconsfield. The primrose was said to be Lord Beaconsfield's favourite flower, and supporters wore bunches of primroses in their hats or buttonholes.

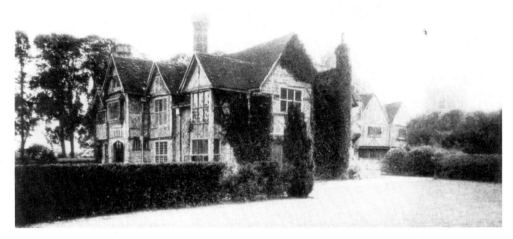

Dorney Court, begun in the early sixteenth century, is a mainly Tudor building. It is the seat of the Palmer family, lords of the manor of Dorney since the seventeenth century.

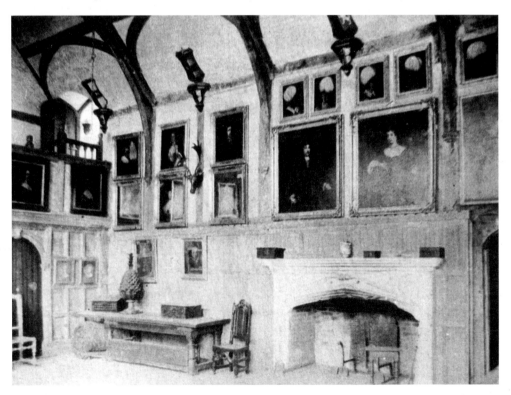

The central beamed hall at Dorney Court, with minstrels' gallery and family portraits, has changed little since Tudor times.

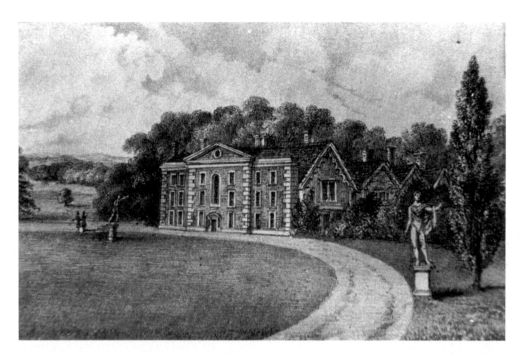

In the eighteenth century Dorney Court, like many other buildings, was given a Georgian frontage and the grounds landscaped as fashionable parkland. This frontage was removed early in the twentieth century and the house was restored to the Tudor appearance that we see today.

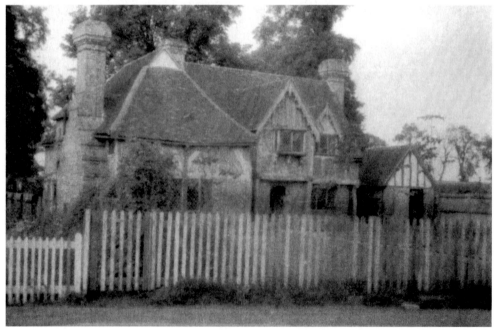

One of the old Tudor houses in Dorney Village. Now called Shepherds Close, it is the last of a group of houses between The Bakery and The Old School Antiques.

Dorney Common still comes under the jurisdiction of the lord of the manor, and regulations are posted on notice-boards on the common. Local farmers exercise common rights to graze their cattle (the cattle grid is just to the right of the telegraph pole). The old school, now an antiques shop, was replaced in 1958 by the new school at Dorney Reach. The chimney of Shepherds Close can be seen to the left of the school.

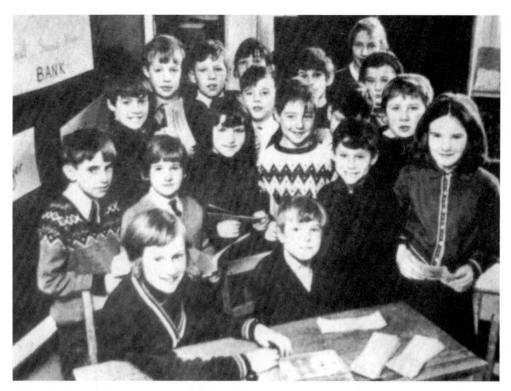

The Dorney Primary School National Savings Bank was started in 1967 to promote saving and to teach the children about the arithmetic of handling money. The bank manager is head girl Christine Burrell-Davies and the cashier is Andrew Grant.

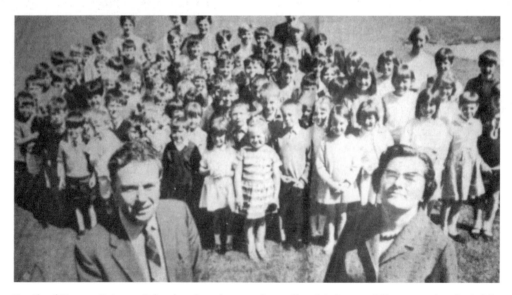

Pupils of Dorney Primary School gathered to say farewell to Mr Leonard Eastgate when he left in 1969 after eleven years as headmaster. Also seen here is teacher, Mrs Audrey Wooller.

The Tufty Club at Dorney School was started to promote road safety among the under-fives. Under the auspices of the County Road Safety Officer, Mr S. Bright, Tufty and his friends gave demonstrations of kerb drill and how to cross the road. Left to right: Sally Collins, Jill Kennedy, David Eastgate, Patricia Eastgate, Tony Apps, Peter Bosher and Ian Wooller.

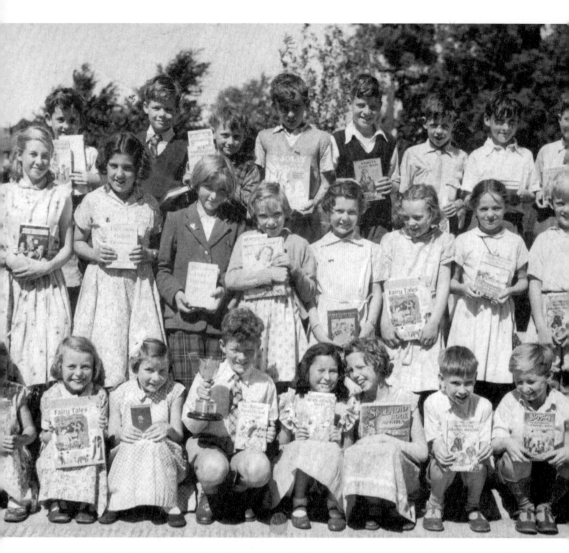

Happy prizewinners display their books and trophies, 1950s. Fairy tales, Biggles and Enid Blyton are among the popular choices.

SECTION FOUR

Hitcham

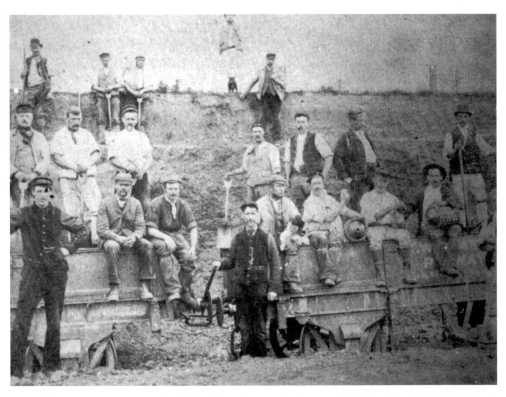

Gravel-digging at The Pit, north of the railway line at Hitcham, c. 1895. A railway line ran through The Pit and two railwaymen are standing by their trucks. Note the dogs, which were used for ratting, and the men on the truck enjoying a drink from their cider flasks. On the extreme right at the front is George Smith.

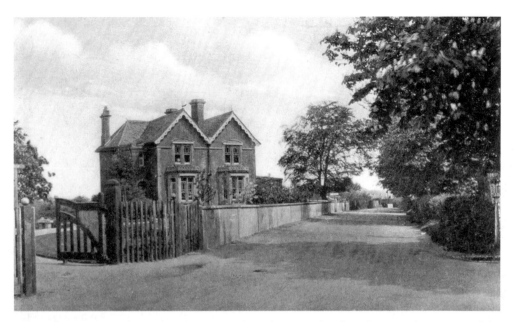

This house, Beechwood, stood at the corner of Hitcham Road and Taplow Road, now part of the Maypole Estate. It was William Wood's original nursery. Wood held a Royal Warrant and won many gold medals at the Chelsea Flower Show. The nursery later took on the Bath Road site, now part of the Bishop Centre.

The old Maypole public house, before it was refurbished. Outside are the children of the landlord, William Horwood.

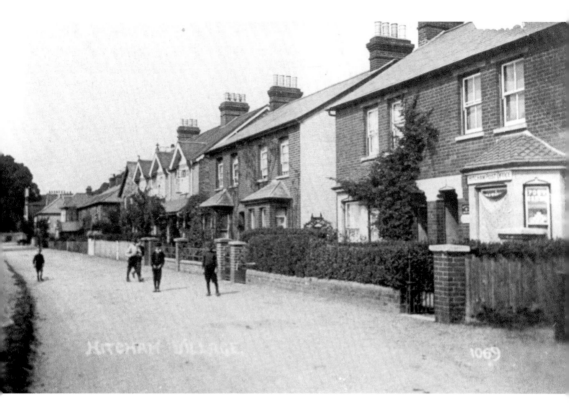

Hitcham Village had its own post office in the first decades of the twentieth century and there is still a postbox on the wall of this house, now on the corner of Byways. The post office, which also sold sweets, was frequented by boys on their way to Taplow Grammar School in Boundary Road.

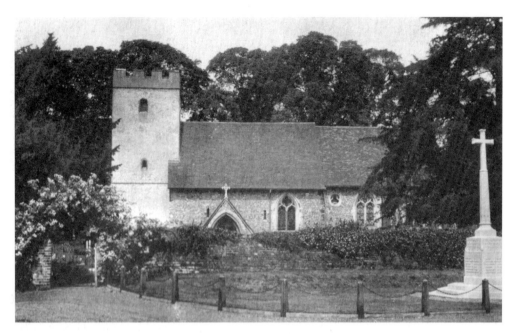

A picturesque view of Hitcham church, with its Norman chancel and Tudor brick tower. Inside is a seventeenth-century memorial to the Clarke family of the old manor house.

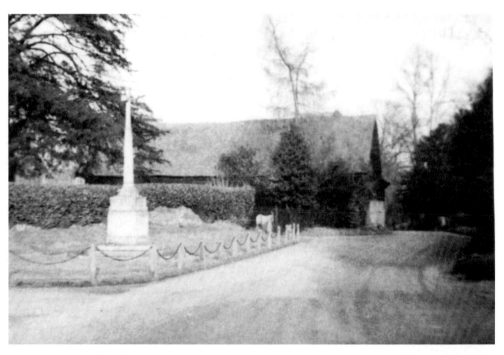

The war memorial in front of Hitcham church. In the 1930s the white donkey (centre) lived in the field behind the tithe barn. This barn, in danger of collapse after a gale in the 1960s, was renovated and converted into a house.

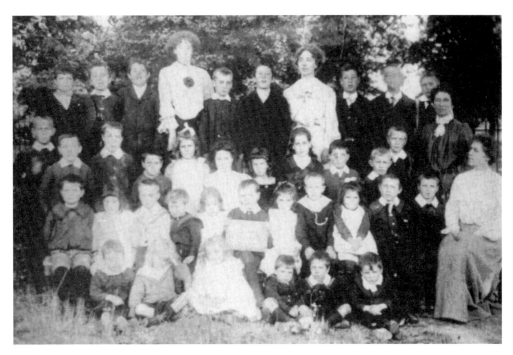

Hitcham schoolchildren in the early part of the twentieth century. From 1811 to 1869 the children of Hitcham attended the school on the Gore, which served Hitcham, Burnham and Taplow. With the coming of the Hanburys, Hitcham became more of a community and acquired its own school in 1869.

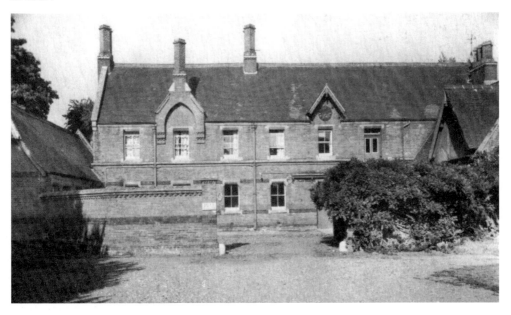

Built in 1869, the stables of Hitcham House became a nurses' home after the Second World War and have now been rebuilt as a small group of houses.

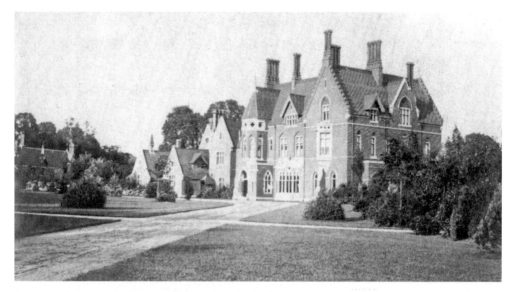

In 1869 brewer George Hambury bought a large area of land in Hitcham and built Blythewood, later known as Hitcham House. He took an active interest in village affairs and built the Mission Hall in Burnham High Street.

George Hanbury, with his wife Mary and family in front of Blythewood. Mrs Hanbury and her daughters took an active interest in Hitcham School, which occupied the house called Cloverdown, next to the church, from 1869 to 1923.

At the front of Blythewood (above) a wagonette for a formal occasion, and (below) a more relaxed form of travel for younger members of the Hanbury family.

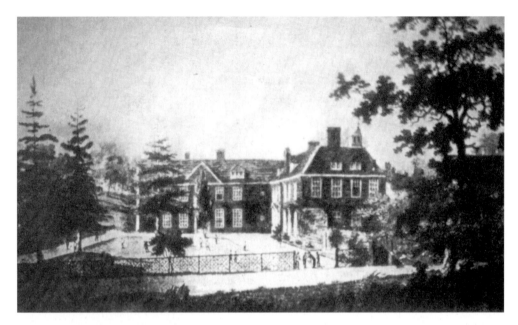

The old Elizabethan manor house, home of the Clarke family, stood to the north of Hitcham Lane at the foot of Hitcham Hill. During the eighteenth century it was a school for 'noblemen and gentlemen'. Among its pupils was John Herschel, son of the astronomer William Herschel. The school was pulled down in 1804 after being extensively damaged by fire. Parts of the walled garden remain.

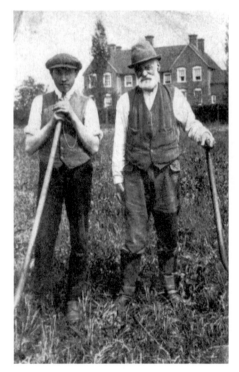

William Smith (left) and Bill Horwood, whose family ran the Maypole, were gardeners at Hitcham Rectory (in the background).

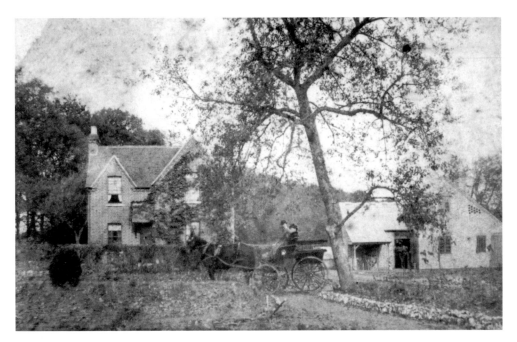

William Bayley and his wife, Nellie (née Webster), in a wagonette in front of the first Westalls at Rose Hill. A new house was built in the 1890s – the larger Westalls of today. The building shown here is now La Geneste, and the cowsheds to the right were converted into a house, now Rose Hill Cottage.

Taplow Common Road. The house in the distance, on the corner of Parliament Lane, is now the Hitcham Vale Montessori School. Beyond was Hitcham common land until Lord Grenville enclosed his estate.

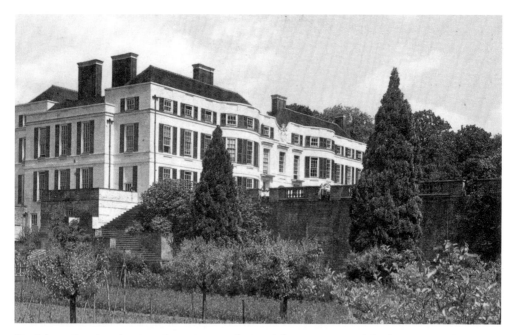

Nashdom, Russian for 'our house', was designed by Lutyens and built in 1908 for Prince Dolgoroukhi, a White Russian emigré, and his wife. They lived there for only a few years and were buried by the south porch in Hitcham churchyard. In 1926 the house became an abbey for Benedictine monks.

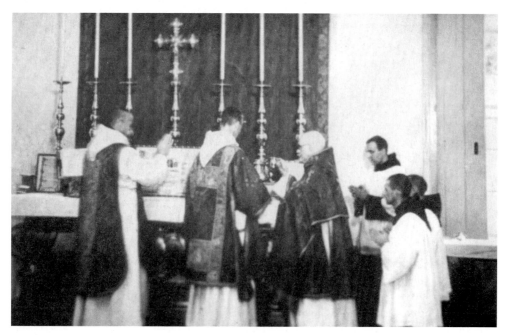

A service in progress in the chapel at Nashdom. By the late 1980s the number of monks was too few to maintain such a large abbey, so they moved to smaller accommodation.

SECTION FIVE

Cliveden
and Dropmore

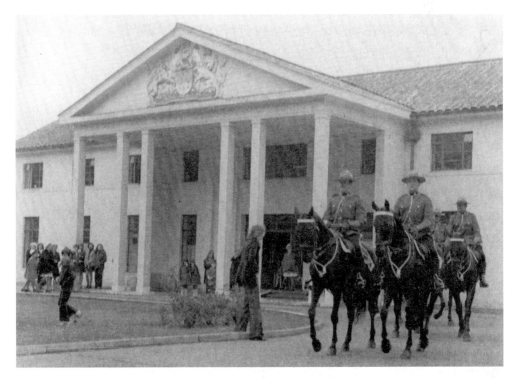

Canadian mounties outside the entrance to the Canadian Red Cross Hospital, Cliveden. It was presented to Britain in 1947, but mounties continued to visit whenever they were in the country. The land on which the hospital was built was Lord Astor's polo field on the Cliveden Estate. This building was erected in the Second World War as a successor to the original wooden construction, which was called the Duchess of Connaught Hospital.

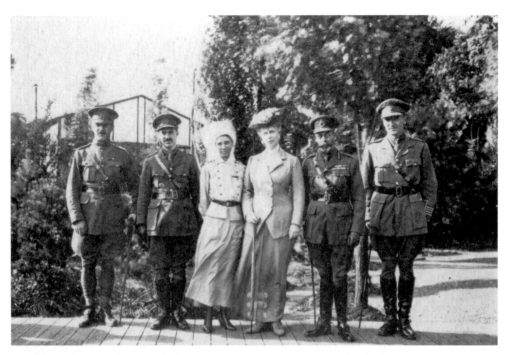

King George V and Queen Mary paying a visit to the Duchess of Connaught Hospital at Cliveden during the First World War. The Duke of Connaught was Ambassador to Canada and the hospital treated wounded Canadian soldiers.

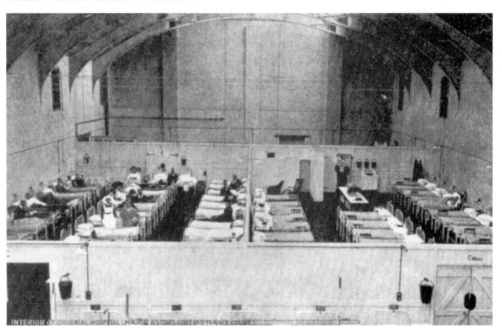

Inside the Astors' covered tennis court at Cliveden, 1914. The building was used to provide beds for wounded Canadian soldiers until their new hospital was ready.

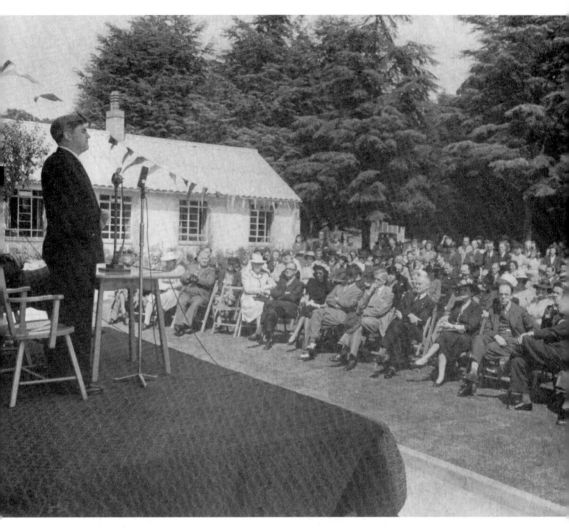

The official opening of Cliveden Hospital, 1947. The Canadians gave the hospital to Britain to use as a general hospital for local patients, and to develop a centre for rheumatic diseases of children. The speaker on this occasion was Aneurin Bevan. In the front row are Lord and Lady Astor.

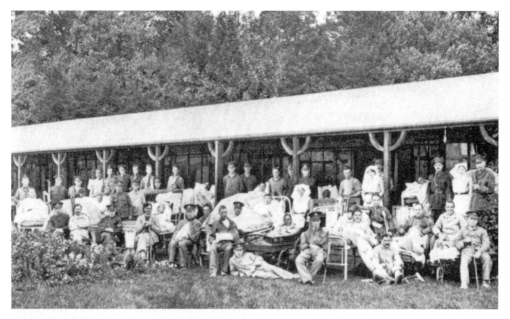

Canadian soldiers outside a ward of the first hospital.

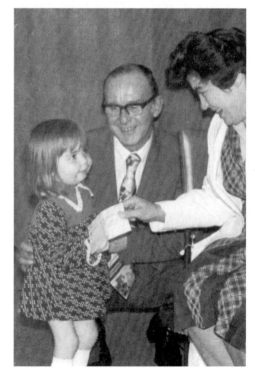

Professor E.G.L. Bywaters was the pioneer of the Research Unit for Rheumatic Diseases of Children at the Canadian Hospital. When he retired in the 1970s Dr Barbara Ansell, seen here receiving a cheque from a small patient, took over the unit.

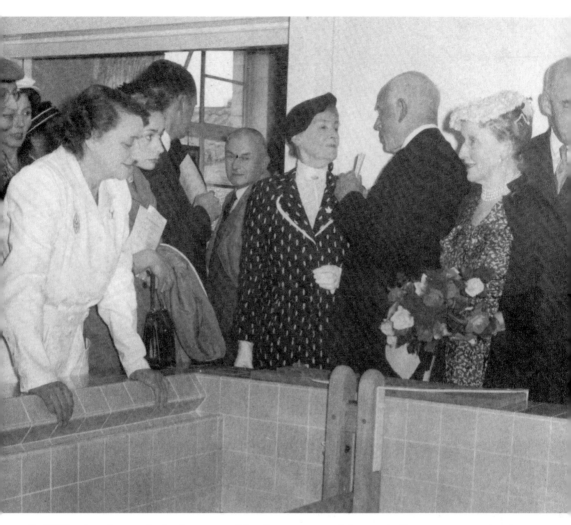

In 1956, when the new hydrotherapy pool for the treatment of rheumatic diseases was completed, Lady Astor, seen with her bouquet, was invited to open it.

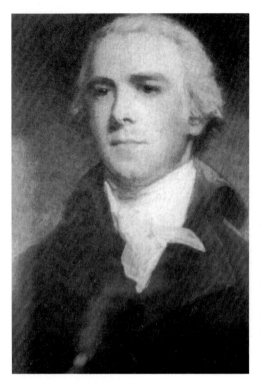

Lord William Wyndham Grenville (1759-1834). Lord Grenville became Speaker of the House of Commons in 1789, married Anne, a niece of William Pitt, in 1792, was Foreign Secretary from 1791 to 1801 and Prime Minister from 1806 to 1807. He acquired land at Dropmore on which he built a mansion (below). He then proceeded to purchase land to increase his original six acres by diverting roads and rehousing people. He is buried in the north transept of St Peter's church, Burnham, beneath the stained-glass window dedicated to his family.

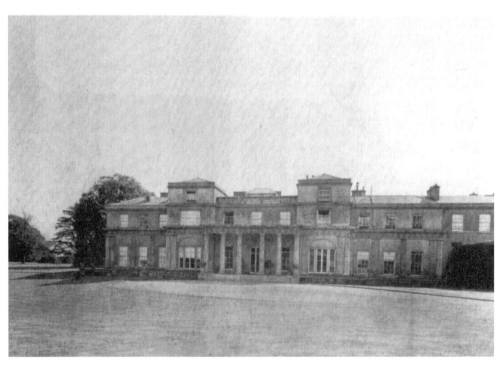

The front entrance of Dropmore House, built by Lord Grenville for his bride.

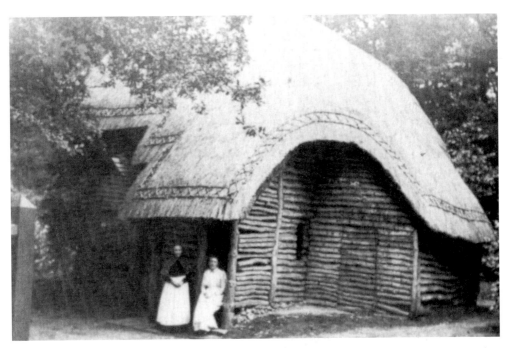

A gatehouse at one of the entrances to Lord Grenville's Dropmore Estate. This is a somewhat primitive yet attractive building, formerly situated on the Hedsor side of the grounds.

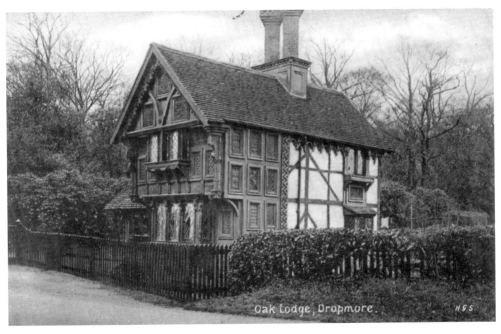

Oak Lodge, a more elaborate structure, at the main entrance to Dropmore remains today. It is covered with carved wooden panels (from pieces of unwanted furniture), which Lady Grenville had fitted.

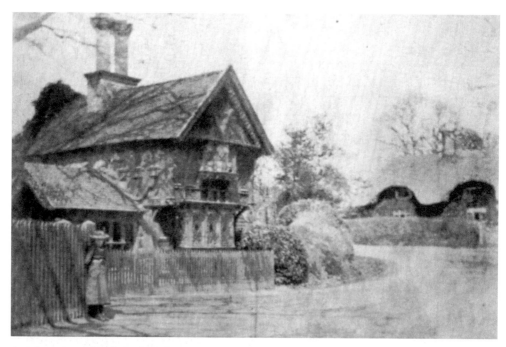

Another view of Oak Lodge, showing its proximity to Dropmore School. The latter, a thatched building, is thought to have been built in the late 1700s and later used as a school.

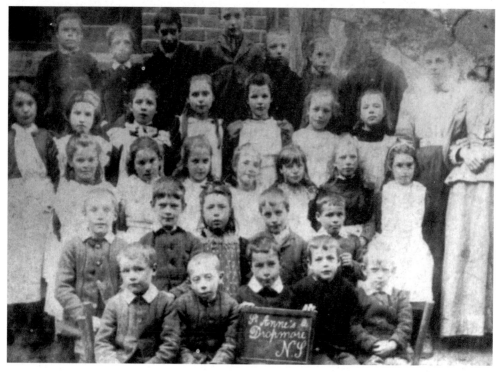

A class of pupils and their teacher at Dropmore National School, *c.* 1905.

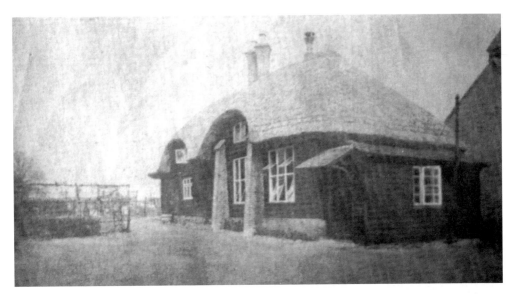

Dropmore School had only one classroom until 1894. It was modernized in the 1950s and '60s and is now used only as a first school.

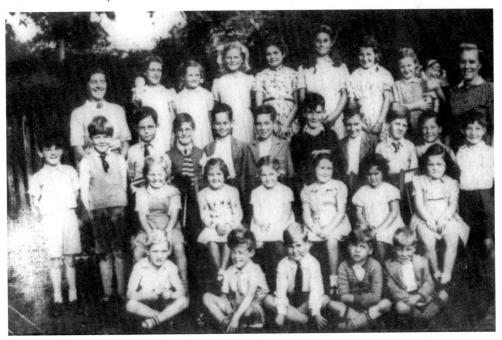

Pupils and staff of Dropmore School, 1949. Left to right, back row: Mrs D. Norman, B. Unwin, D. Newman, M. Burnham, R. Anderton, J. Stottel; B. Searl, E. Rackley, Mrs Newbold. Third row: D. Bates, D. Gillespie, R. Houchin, R. Quelch, D. Stotter, T. Donovan, A. Macmillan, D. Bradshaw, M. Boxall, R. Curtis, B. Franklin. Second row: C. Norman, K. Douglas, S. Franklin, J. Ravenhill, A. Gates, J. Bates. Front row: D. Prior, P. Unwin, N. Houchin, I. Gillespie, L. Burnham.

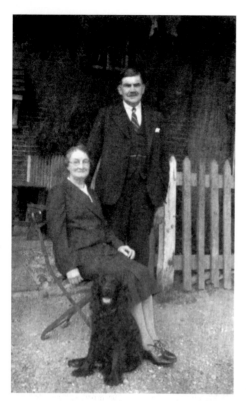

Landlord of the Jolly Woodman pub at Dropmore, Mr Unwin, with his wife and dog outside the pub, *c.* 1930.

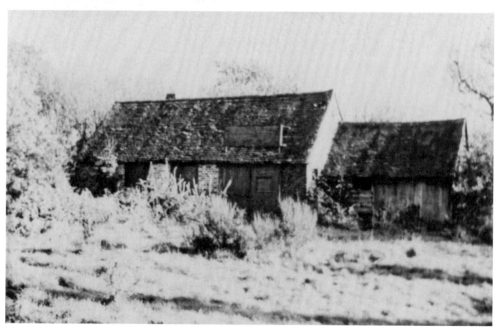

The old forge at Littleworth Common, Dropmore, was the village smithy as well as serving passing travellers. The remains of this deserted building still exist.

SECTION SIX

Burnham Beeches
and Farnham

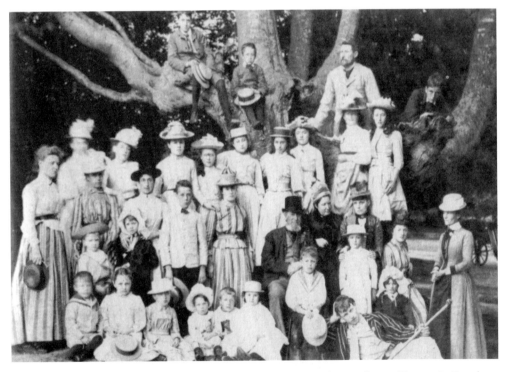

Deverills' schoolchildren and parents on an outing from Burnham. These old trees in Burnham Beeches provided a picturesque background for group pictures. Photographers set up their cameras on Seven Ways Plain, where most visitors gathered. Back row, third from left is Miss Jessie Deverill and middle row second from left is Miss Eva Deverill. Seated in the centre are their grandfather, John Deverill, with his wife, and his daughter-in-law, Mrs Harriet Deverill, who started the school.

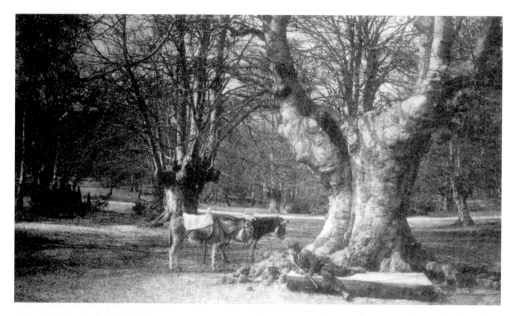

These donkeys were a familiar sight in the Beeches during the first half of the twentieth century. Kept by the Pusey family, they gave rides to many of the Londoners who flocked to the countryside for a day of rest and refreshment in 'leafy Bucks'.

Relaxing in the Beeches in around 1890 are Jim Tilbury and his friends, who include Mr Cox and Jack Weekes.

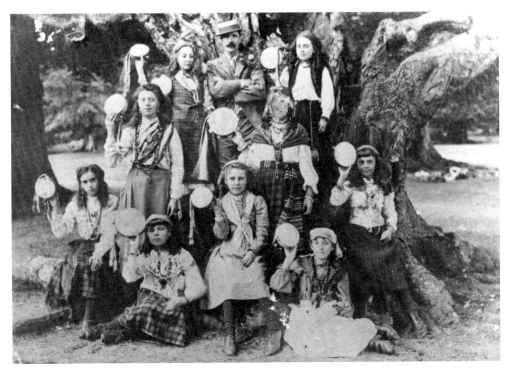

Girls of Burnham Village School in around 1903, posing in gypsy costume from a school pageant for a celebratory photograph in the Beeches. Mr Kent, headmaster from 1888 to 1908, is with them.

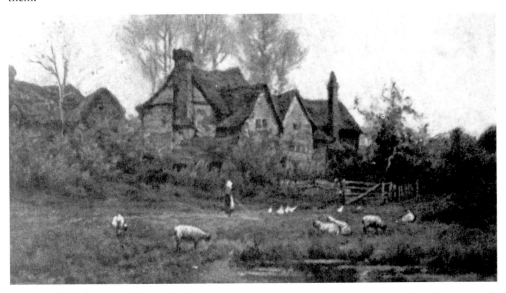

On the outskirts of the Beeches were a number of cottages and farmhouses. This house stands opposite Swilly Pond in Crow Piece Lane. Swilly Pond is the lowest of the three ponds in the Beeches.

Pumpkin Hill marks the southern edge of Burnham Beeches, beyond the golf course. Until the end of the nineteenth century farmland stretched up to this boundary. A large part of this land belonged to Upper Britwell Farm.

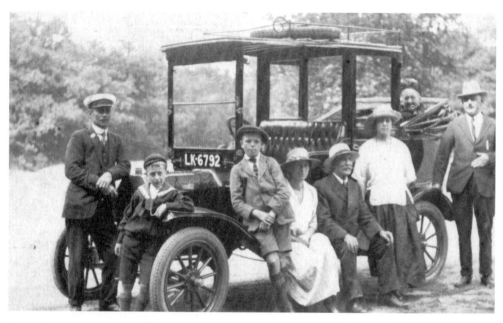

The old lady in the back of the car is Mrs Simmonds, standing beside her is Mr Bradley and the driver (far left) is Harry Watts.

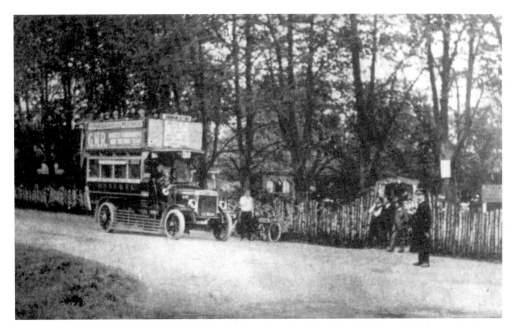

Wingrove's Tea Gardens, a very popular spot from the 1890s, stood where the new estate of Nightingale Park is today. Omnibuses ran from both Slough and Burnham stations. The Burnham Beeches swimming pool was between Wingrove's and Grenville Lodge. Another tea garden, Macro's, stood at the west end of Lord Mayor's Drive.

Grenville Lodge later became The Brown Owl and Henry's night club in Hawthorn Lane. Henry's has now been sold and has reverted to the name of Grenville Lodge. This advertisement is from a book published in 1885.

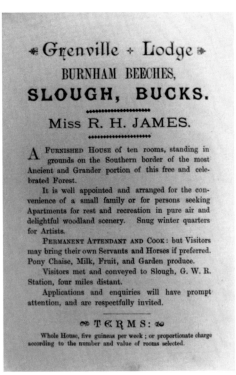

Grenville ✦ Lodge ✦

BURNHAM BEECHES,

SLOUGH, BUCKS.

Miss R. H. JAMES.

A Furnished House of ten rooms, standing in grounds on the Southern border of the most Ancient and Grander portion of this free and celebrated Forest.

It is well appointed and arranged for the convenience of a small family or for persons seeking Apartments for rest and recreation in pure air and delightful woodland scenery. Snug winter quarters for Artists.

Permanent Attendant and Cook: but Visitors may bring their own Servants and Horses if preferred. Pony Chaise, Milk, Fruit, and Garden produce.

Visitors met and conveyed to Slough, G. W. R. Station, four miles distant.

Applications and enquiries will have prompt attention, and are respectfully invited.

TERMS:

Whole House, five guineas per week ; or proportionate charge according to the number and value of rooms selected.

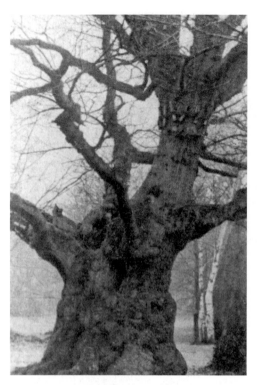

Druid's Oak, believed to be about four hundred years old, stands on Seven Ways Plain to the east of Lord Mayor's Drive. Behind it are two ponds, formed in around 1800 when the stream was dammed for the purpose of sheep-washing.

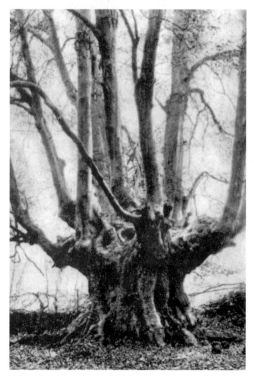

His Majesty, the largest tree in the Beeches and believed to be the biggest beech butt in England, stands at the bottom of Pumpkin Hill on the boundary of the golf course.

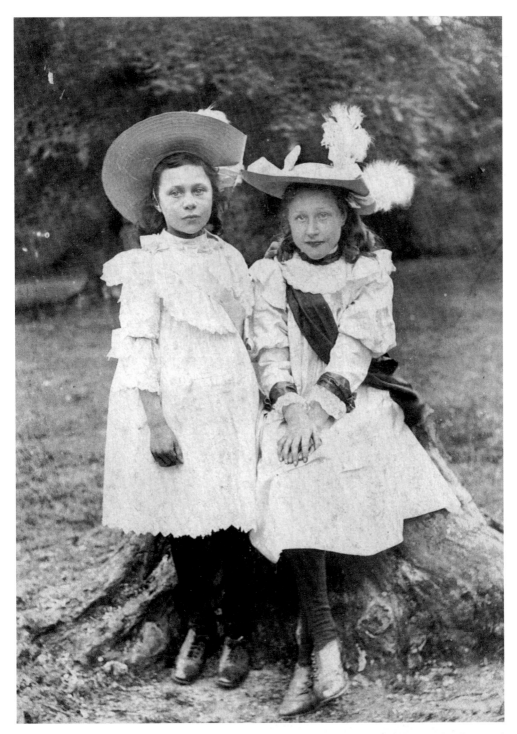

Florence and Ethel Harris in 1899, when an outing to the Beeches called for Sunday hats and finery.

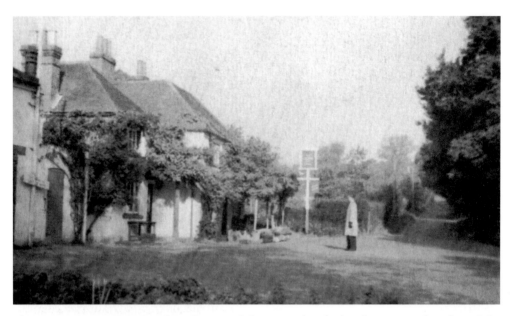

The Crown inn at East Burnham has stood for many hundreds of years on the edge of the Beeches. After the Eyre family left Allerd's Manor in the eighteenth century, the manorial court was transferred from there to The Crown, where it was held from 1796 to 1855.

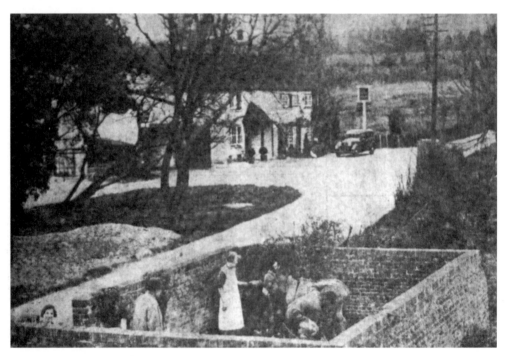

On the opposite side of Crown Lane is the old Manor Pound where stray animals used to be kept. Here the donkeys are being checked by the vet for good health before being released on to common land.

A fifteenth-century barn at Allerd's Farm opposite East Burnham Park, the remains of which can still be seen. The farm took its name from the old Allerd's Manor Farm behind The Pound, which was pulled down with the manor house in 1837.

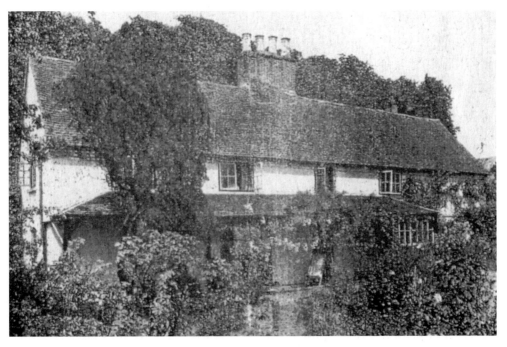

Allerd's Farmhouse, which in the 1930s became Allerd's Manor Guest House. Directions for reaching it said, 'turn off at the old "candle-snuffer" pump-house in the centre of Farnham Royal'.

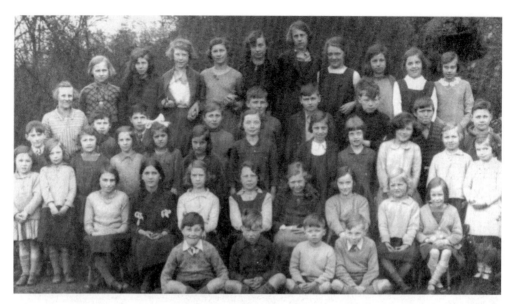

East Burnham School, 1935. Back row, left to right: Miss Fleet, V. Arnett, A. Wiggins, F. Arnett, M. Dobson, Margery?, J. Arnett, J. Howse, D. Newman, J. Leek, L. Skull. Fourth row: B. Porter, S. Matthews, -?-, J. Tozland, B. House, R. Nut, G. Smith, B. Bowler, J. Newman. Middle row: -?-, E. Newman, -?-, D. Wiggins, D. Bowler, E. Newman, -?- Gill, I. Arnett, -?-, I. Dobson, C. Arnett, -?-. Second row: W. Nut, D. Bowler, A. Dobson, -?-, B. Quarterman, D. Portel; J. Arnett, E. Porter. Front row: -?-, ? Smith, -?-, R. Nut.

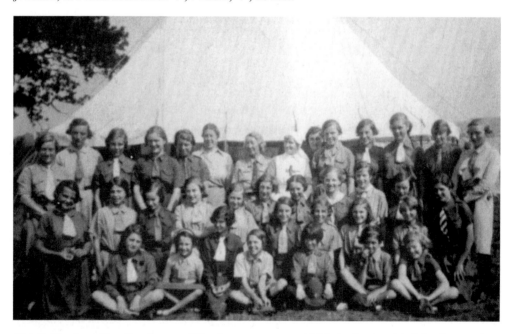

Girl Guides from East Burnham and Farnham at camp, c. 1936. At the centre is Miss Foster, their captain. Fourth from the left in the back row is Joyce Howse. Dolly Porter is in front of her.

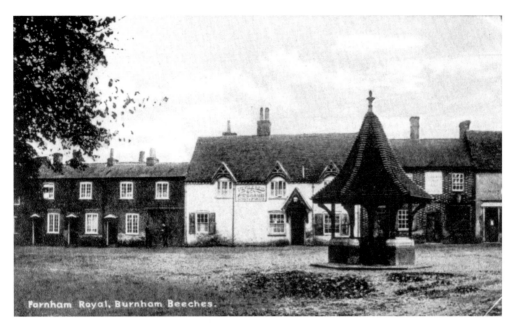

The old pump stood in the centre of the road at Farnham Royal until around 1970, when it was moved to the grounds of Farnham Park. It survived as a local landmark and meeting place long after it had outlived its original use.

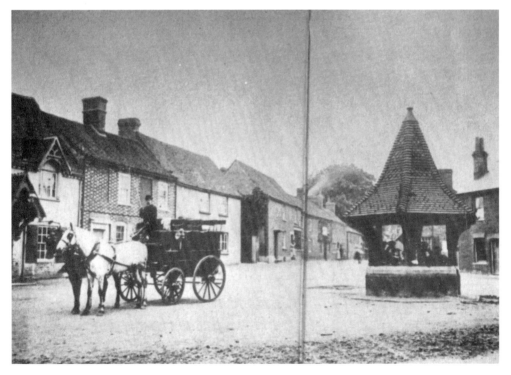

Wagonette waiting for the group of schoolchildren in the shelter round the pump, 1895.

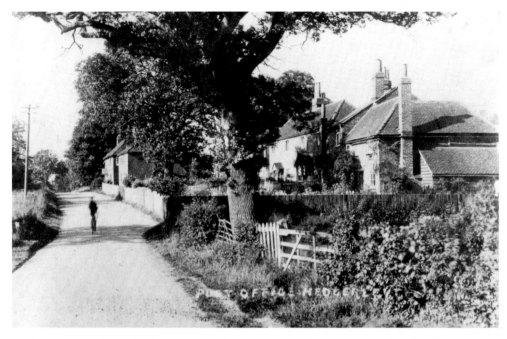

Hedgerley post office, 1920s. Pot Kiln Cottages take their name from the old kiln that once occupied the site behind the post office. In 1740 there was also a kiln at the bottom of Hedgerley Hill.

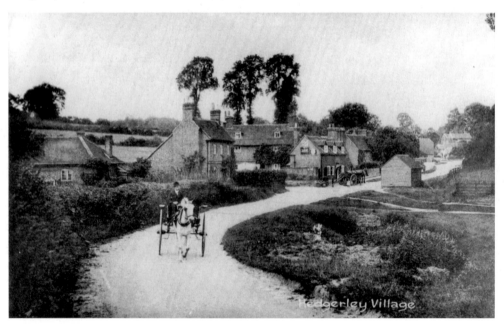

Hedgerley, c. 1910. At the old Brickmould pub, barrels are being unloaded from the dray outside. The pub was demolished in 1955 and the new building was erected on the site of the cottages to the rear, which were taken down in 1937.

SECTION SEVEN

Britwell

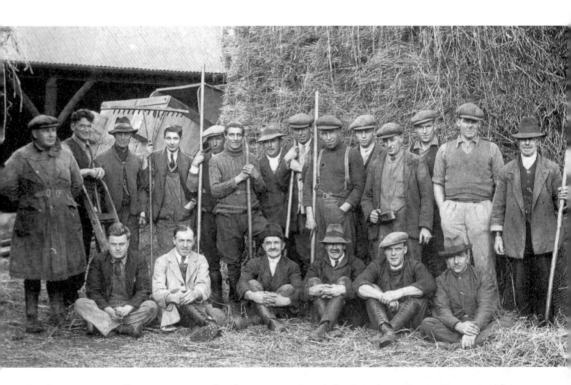

Workers at Britwell Farm, 1930s. the farm was part of the Burnham Grove Estate run by Edward Clifton-Brown. Previously Britwell Upper Farm, the old farmyard is now Lidstone's. Standing, left-to right: ? Rose, ? Stanley, -?-, ? Rowe, -?-, ? Bunce, -?-, ? Herbert, -?-, ? Keen, ? Goodchild, ? Coxhead, ? Herbert. Seated: Ken Light, -?-, G. Gunn, ? Hoskins, -?-, ? Brooklin.

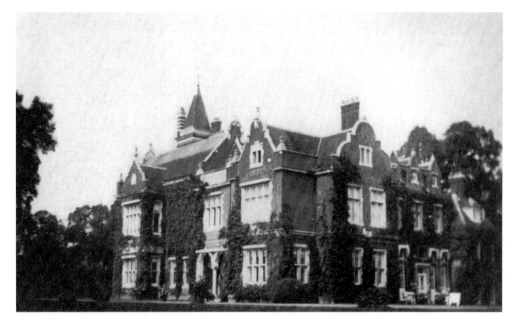

Britwell Court was the home of William Henry Miller, who collected the famous Britwell Library. His heirs, who took the name Christie-Miller, lived there through most of the nineteenth century. The right-hand wall seen here was the conservatory onto which the chapel was built when it became the House of Prayer, the home of an order of Anglican nuns, in 1920. It is now an office complex renamed Grenville Court.

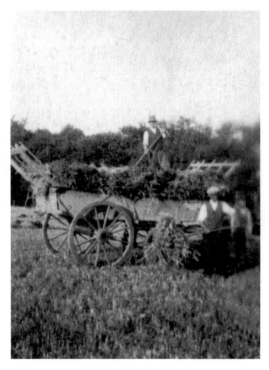

Mr Gunn with the haycart at Britwell Farm, 1930s.

Britwell Lower Farmhouse in the 1890s, before Britwell Road was diverted to its present position. The old road ran along the back of Upper Farm, past the front entrances of both Britwell Court and Lower Farmhouse, and onwards to the Five Points.

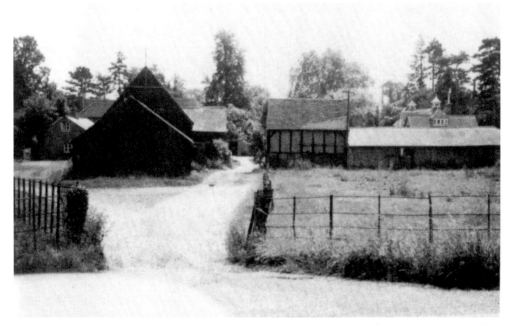

Looking south from Britwell Road to the yard and buildings of Lower Farm. In the early years of the twentieth century Lower Farm ceased to be a working farm. Upper Farm became part of Burnham Grove Estate.

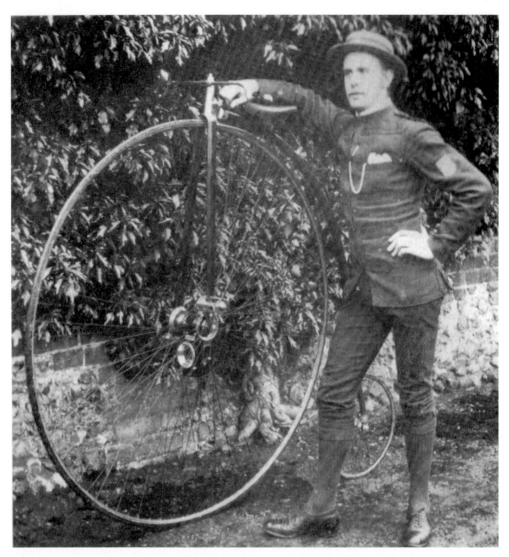

Alfred Bayley was born at Britwell Lower Farm in 1865. He cycled to Land's End on his penny-
farthing in the 1890s. In his later years he owned fruit orchards on the sites of Lent Rise School
and Bayley Crescent. He was known as 'Tiggy' Bayley, an irascible old farmer, by the boys who
raided his orchards.

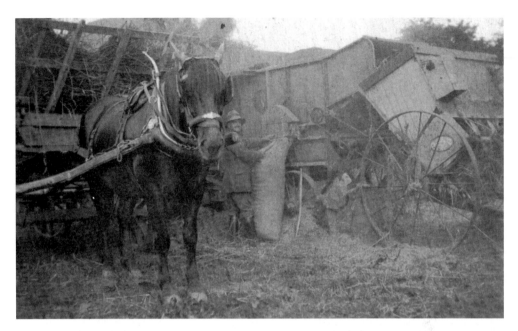

Harvest time at Britwell Farm, 1920s. Horses had not yet been replaced by tractors. George Gunn is collecting corn from the hopper of an early threshing machine. The straw came out through the chutes at the near end.

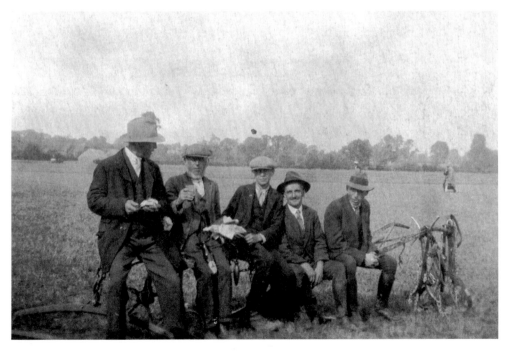

Tea break for the award-winning Britwell Farm team during a ploughing match, 1938. In the 1930s ploughing matches were an annual event.

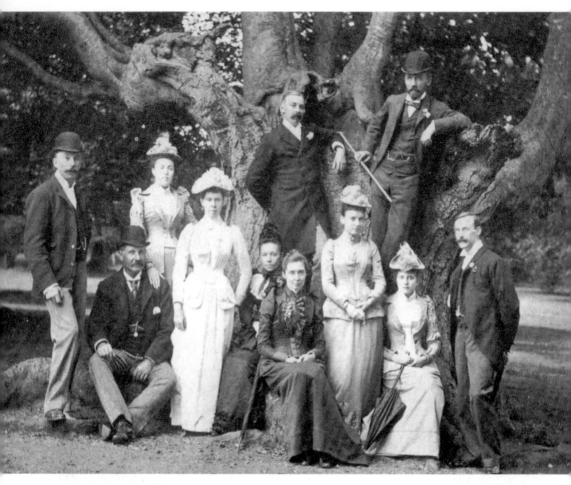

Members of the Bayley family and their friends, *c.* 1900. Standing, left to right: Jack Bradford, Emily Webster, Fan Bayley, Harry Baldwin, Edith Bayley, George Webster, Fred Bayley. Seated: John Webster, Mrs Barnet, Mrs Bradford, Daisy Webster. Harry Baldwin ran the Britannia Foundry in Burnham High Street and was captain of the fire brigade. The Webster family originally farmed at Dorneywood, and were corn and coal merchants in the village for many years.

The stables at Lynch Hill Farm, with the children of farmer Jack Keen: Cicely, Alec and Desmond. The family came to Lynch Hill, which was part of the Grove Farm Estate, in 1925.

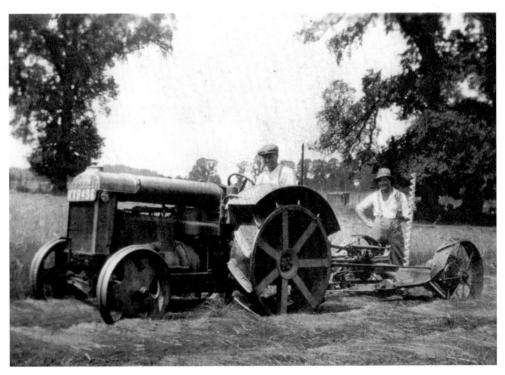

Jack Keen driving an old Fordson tractor. Jack was responsible for all of the tractors on the farm and is said to have been one of the first men in Buckinghamshire to drive one. He was also a first-class ploughman.

Lynch Hill Farm stood at the top of the hill near the present Grove Tavern. It was a mixed farm with cereals, sheep and pigs, a large dairy herd and its own dairy. A working farm until around 1950, it was demolished a few years later to make way for the Britwell Housing Estate.

Lynch Hill dairymen won the Gold Cup for the cleanest milk in the county for five consecutive years. Standing, left to right: Gregory Meek, Mr Light. Seated: George Claridge, Ken Light.

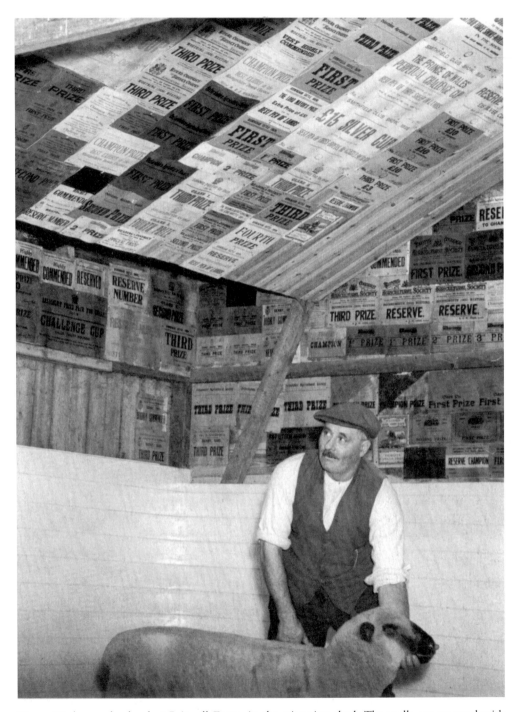

Harry Wadman, shepherd at Britwell Farm, in the trimming shed. The walls are papered with certificates awarded to the estate's prize-winning flock at many agricultural shows.

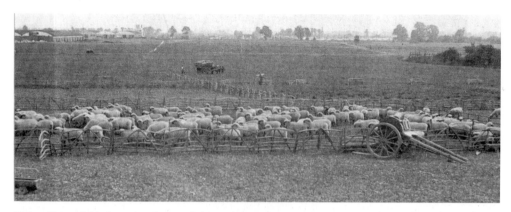

Sheep being folded on land rented from the trading estate, with the Mars factory and other early buildings in the background. Beyond the woods on the right are Haymill pond and the millhouse.

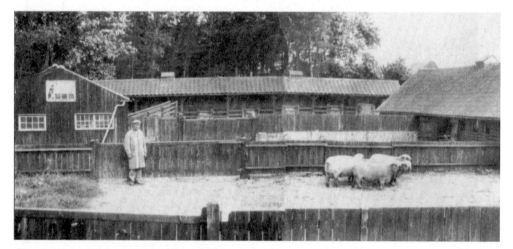

The sheep sheds that housed the famous Hampshire Down flock were in Grove Road between the Cherry Orchards and The Grove (now Burnham Beeches Moat House Hotel).

The wedding of Winnie Coxhead, outside the farm cottages. The Coxhead family worked at Lynch Hill Farm in the 1920s and '30s.

Mrs Gladys Harris and Mrs Joyce Stebbings, with a group of Girl Guides, meet Lady Baden-Powell at Lynch Hill School, *c.* 1964.

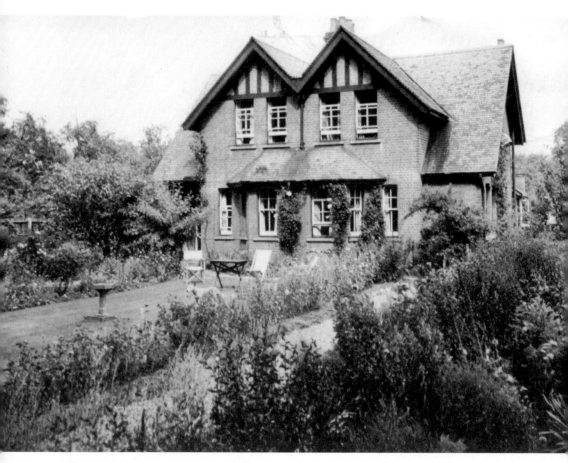

Pound Cottage was the home of Cecil Twist and his family. Cecil was land agent-cum-manager of the Burnham Grove Estate Farm from 1921 to around 1950, when the estate was sold. A small cul-de-sac called The Pound stands there now.

SECTION EIGHT

Cippenham

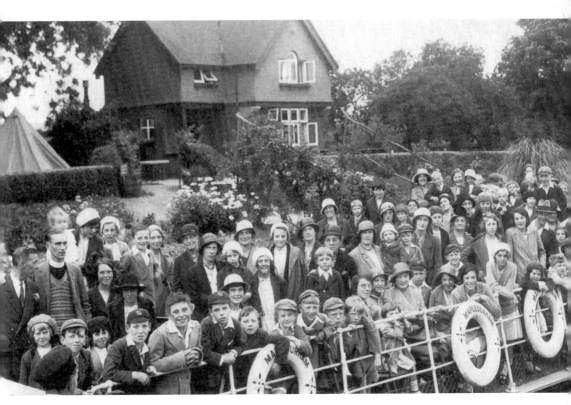

A day out on the river was a special occasion in 1932. This group at Boveney Lock was on a Sunday school outing from Cippenham Mission Hall.

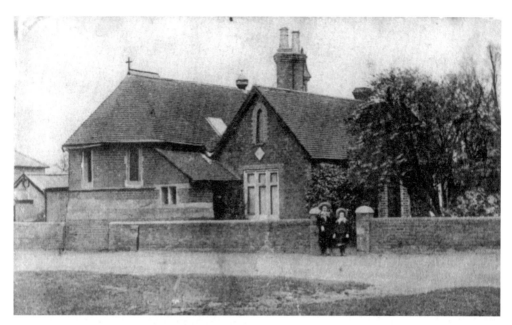

Cippenham Mission church and the adjoining school, the first to be built in the village. It was replaced by the school in Elmshott Lane in the 1950s.

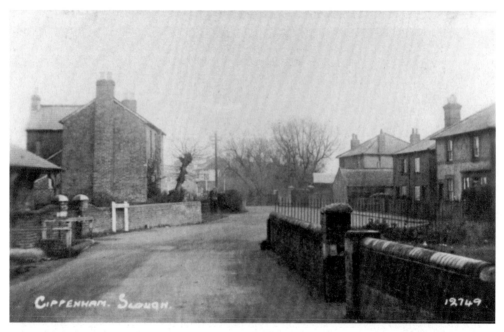

Cippenham Green looking towards Slough, *c.* 1935. On the right is part of the Mission School wall.

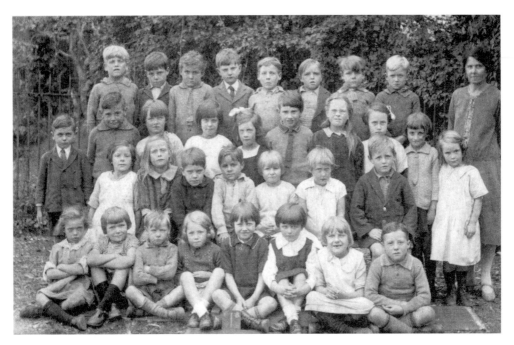

A class at the Mission School, *c.* 1930. The group includes Albert Hill, Philip Hill, Ray Grant, Doris Winslow, ? Cox, Eric Horwood and John Godding.

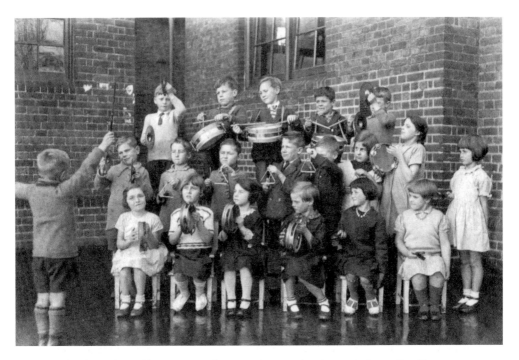

A school band conducted by Eric Angel, 1932. Among the players is Joyce Berrill.

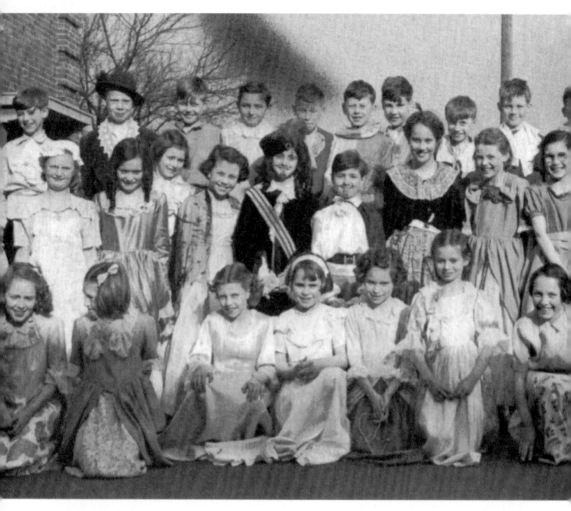

Cippenham School play, 1955, depicting the Restoration period when Charles II returned to the throne.

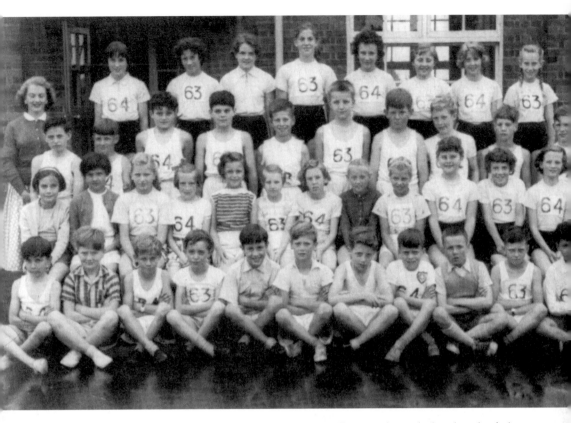

Cippenham Middle School sports teams, 1955. Carol Hill is at the right-hand end of the second row.

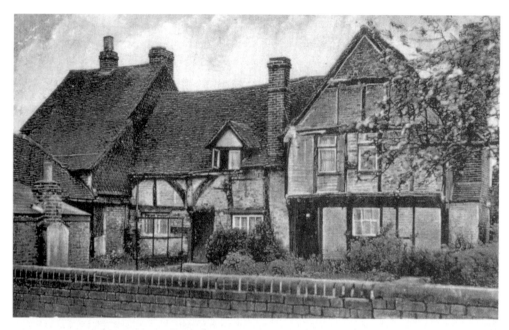

The central cottage in this row of Tudor buildings, pictured in the early twentieth century, was the Jolly Gardener. The row was demolished in the 1960s.

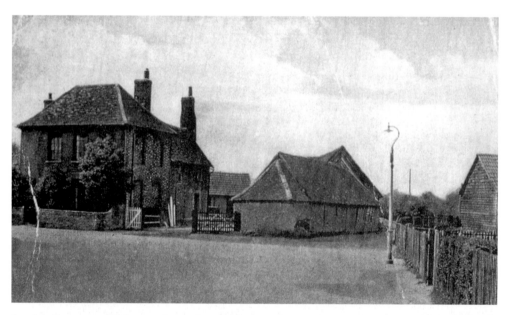

Lewin's Farm stood in Lower Cippenham Lane near the British Legion. Here many local children learned to ride ponies. The farm was demolished in the 1970s to make way for new houses.

This grain store, on mushroom-shaped stones to deter rats, is in the garden of Cippenham Place (below), a sixteenth-century Tudor house that stands in Lower Cippenham Lane, formerly Place Farm.

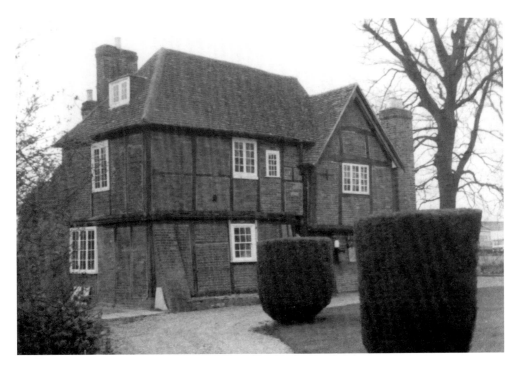

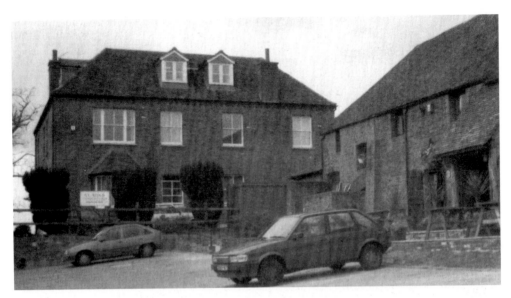

Cippenham Court Farmhouse. The stables (right) are now the Old Barn Restaurant in Cippenham Lane. In the nineteenth and early part of the twentieth century the land was farmed by the Headington family. The fields stretched beyond the Bath Road, the site now covered by the trading estate.

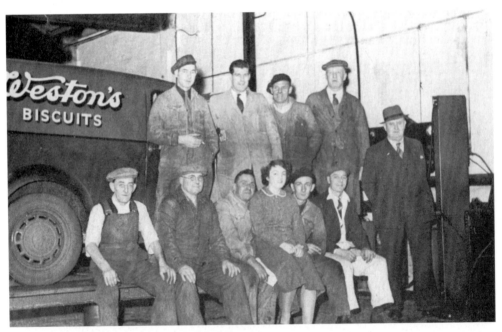

Weston's biscuit factory was one of the earliest to be built at the Cippenham end of the trading estate which turned Slough into an industrial town. Mr Berrill (seated second from left) and colleagues are pictured in around 1950.

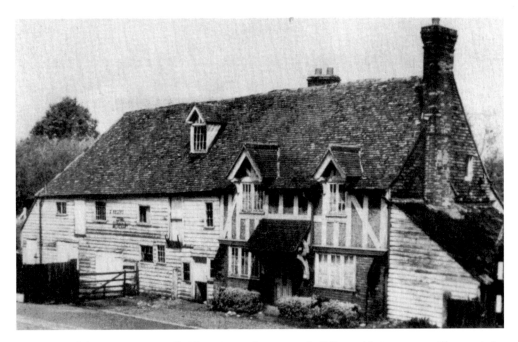

The old mill house at Hay Mill. This sixteenth-century building with its water-mill served the local farmers for centuries until its demolition in the 1960s. The pond behind the mill, which was used to breed swans in the thirteenth and fourteenth centuries, is now almost dry, but has become a conservation area. Water meadows stretched back to the present Britwell housing estate and Lammas Pond.

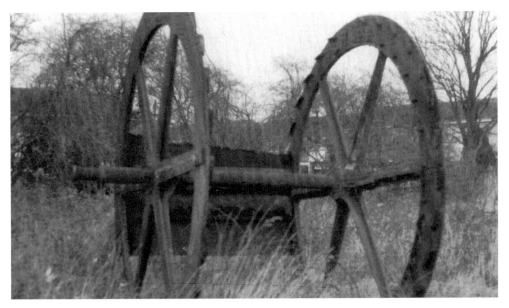

The remains of the Hay Mill water-wheel in a field at Cippenham. It is hoped that this will be returned to the conservation area, together with the mill stone.

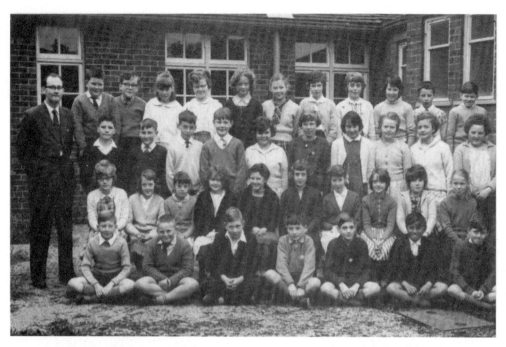

The new Cippenham School in Elmshott Lane, 1955. The teacher is Mr Kincaid and sixth from the left in the third row is Pamela Hill.

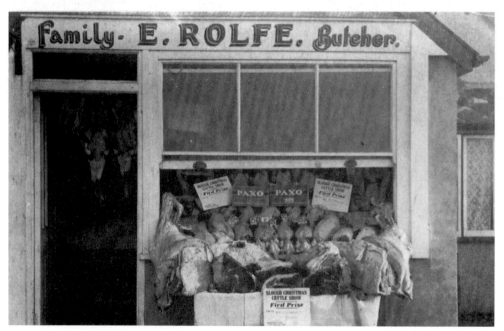

Rolfe's butchers shop in Elmshott Lane, 1926.

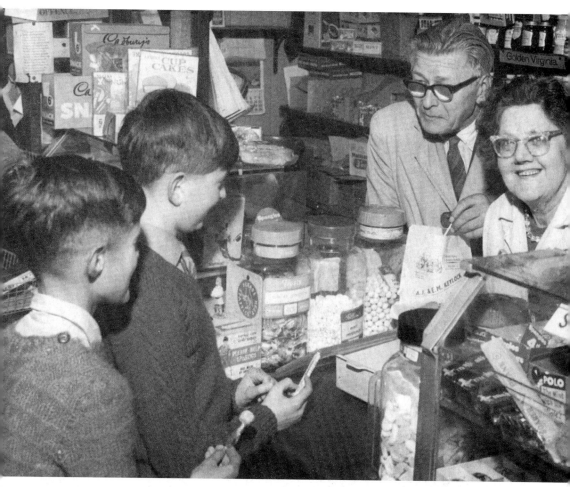

Later the butchers shop (opposite) became a grocers run by Mr and Mrs Keylock, here serving sweets, possibly to pupils from the school on the opposite side of the road.

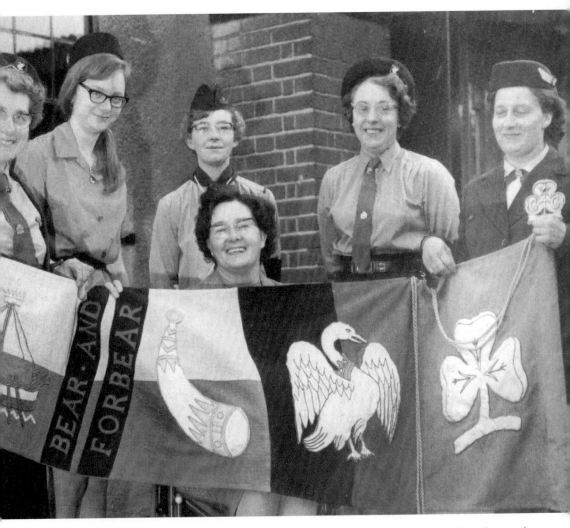

This banner took 150 hours to complete and was made by Mrs Joan Smith (seated). It depicts the Girl Guide badge, the Bucks swan, a drinking horn (representing Taplow) and the Mercian badge (representing Cippenham). Standing, left to right: Joyce Stebbings, Gillian Fryer, Lesley Smith, Sylvia Strong and Sheila Birtchnell.

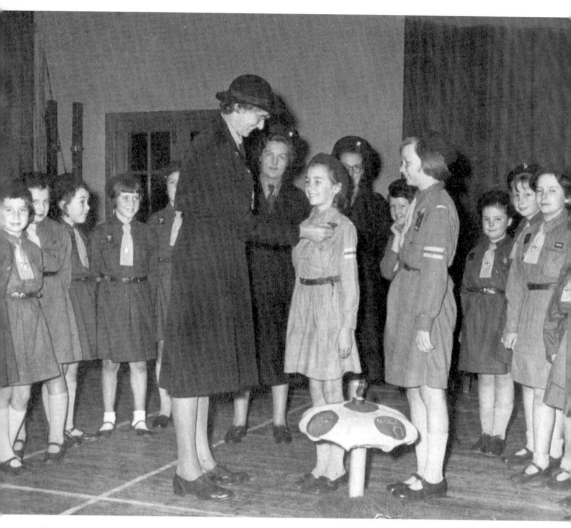

The 2nd Cippenham Brownie Pack, re-formed in 1957. These are the first Brownies to receive their wings from Miss Nancy Treleaven.

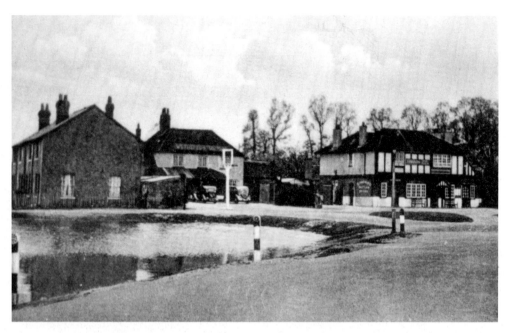

The pond on Cippenham Green, with the surrounding public houses, was the focal point of village life, *c.* 1935. On this side of the pond were The Barley Corn and The King's Head. On the opposite side (below) was The Swan.

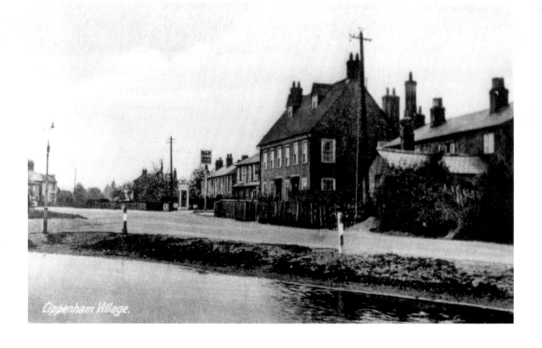

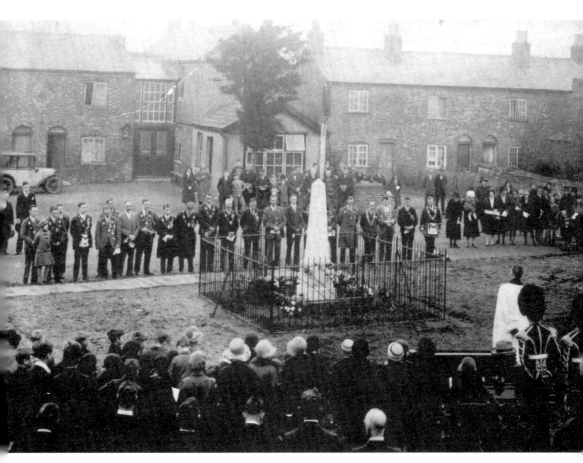

An Armistice Day service around the war memorial on Cippenham Green, 1920s. Later the cenotaph was moved further to the south. The buildings in the background have been replaced by The Swan public house and a row of shops.

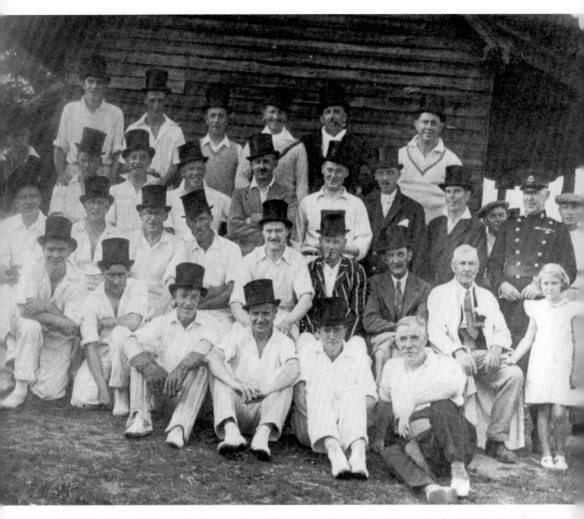

The Top Hat cricket match was an annual event on Cippenham Green in the 1930s. Seen here by the old thatched pavilion (now gone) are the Cippenham and Burnham teams, including Dr Summers, Dr Jacques, Mr Griffiths and Charles Griffiths.

SECTION NINE

Burnham Activities

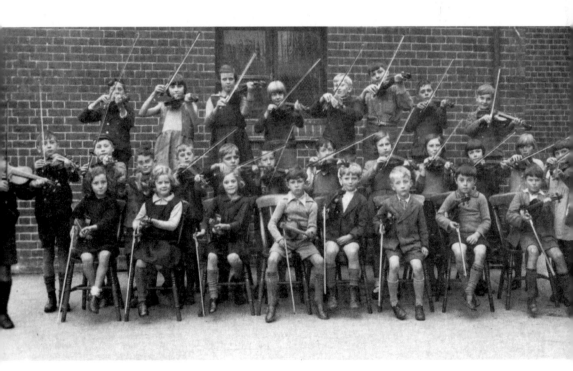

Budding violinists at Burnham Church of England School, 1935. Back row, left to right: -?-, -?-, -?-, A. Williams, -?-, ? Adaway, J. Cory, -?-. Middle row: ? Webb, -?-, E. Harding, A. McIllwraith, -?-, J. Humphreys, S. Brooklin, R. Small, -?-, -?-, J. Brookling, G. Holcombe, B. Davis, R. Goodrham. Front row: A. Rhodes, D. Watts, D. Adaway, D. Blackman, R. Adaway, M. Anthony, A. Bloomfield, -?-.

The infants school's first May Day ceremony, 1931. Left to right: G. Lines, C. Williams, M. Henson, J. Harvey, P. Partner, C. Hulm, -?-, -?-, M. Harris (May Queen), P. Sands (trumpeter).

May Day procession at the infants school, *c.* 1935. Left to right: G. Bleines, O. Boor, -?-, S. Holloway, J. Hearn, -?-, -?-, ? Webb.

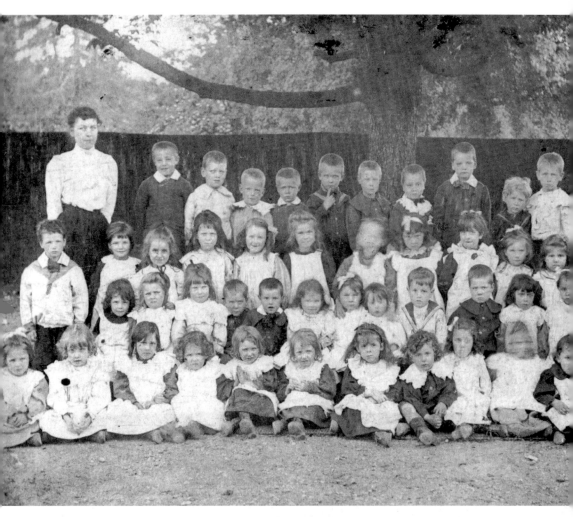

Children at the infants school. This school stood opposite the south gate of St Peter's churchyard from 1844 until 1963. Judging by the clothes this was probably at or before the turn of the century. Many children look too young to be of school, age, but sometimes younger members of the family were taken along by elder sisters when their mothers were working.

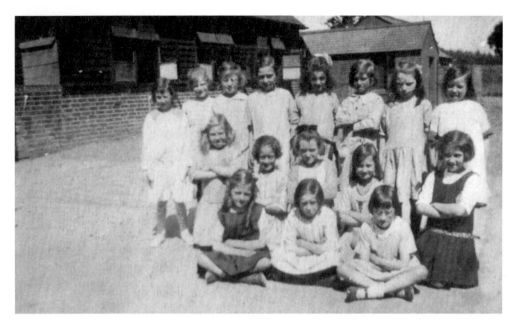

Girls at the Church of England School in the boys' playground, 1924. In the background are brick-built toilets containing lead drinking cups on chains. Back row, left to right: D. Wright, P. Woodward, J. Bradley, F. Gunn, -?-, R. Bond, -?-, -?-. Middle row: J. Blackman, D. Henson, W. Trotman, G. Butler, -?-. Front row: J. Lechmere, -?-, -?-.

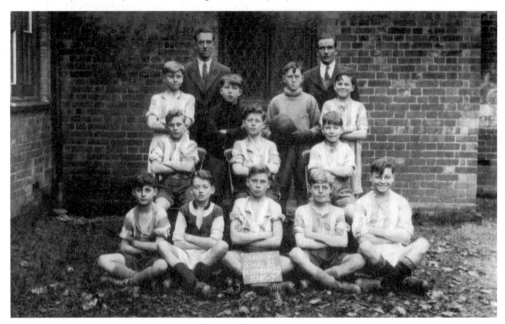

Burnham School Intermediate Football XI, 1947. The masters are Mr Birmingham (left) and Mr Arthur. Back row, left to right: G. Boddy, -?-, M. Pratt, E. Dawes. Middle row: ? Gough, D. Wall, P. Sturgess. Front row: I. Bunce, D. Johnson, R. Watts, K. Wheeler, R. Manhood.

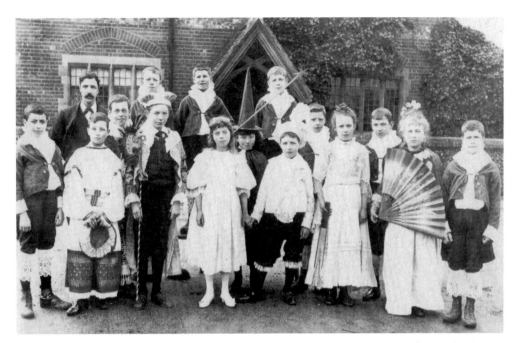

Outside the School House, Church Street, *c.* 1907. Senior pupils are dressed for a school play, which the headmaster Albert Kent encouraged them to put on. Kent is seen here not long before he died, it is thought from overwork.

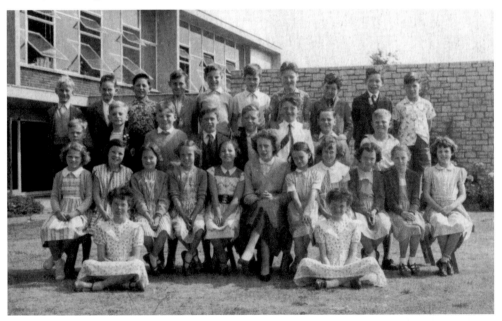

A class at Priory School, 1960s. The teacher is Mrs Joan Haley. On her left is Susan McCaulden. In the back row, fourth from right, is Brian Hopson, and the twins at the front are Barbara and Sandra Knott. The school was built in the 1950s to cater for the new Priory housing estate.

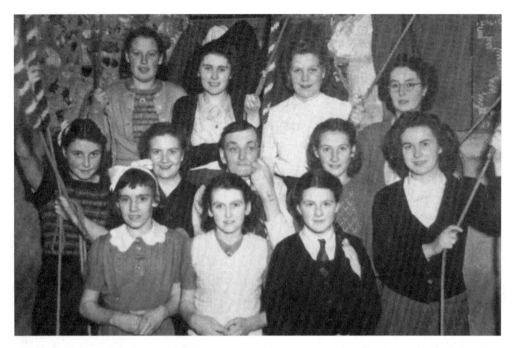

Inside the belfry of St Peter's church, 1940s. In the centre is G. Gilbert, ringing master, who, during the war, taught this band to ring using muffled bells. Back row, left to right: J. Hearn, M. Jaycock, G. Murkett, M. Pemberton. Middle row: ? Webb, F. Murkett, -?-, .J. Broomfield. Front row: -?-, -?-, ? Maybank.

The top and tail of the bell-ringing team at a wedding, 1950. A. Simpkins, aged eighty, and B. Stainthorpe, aged eight.

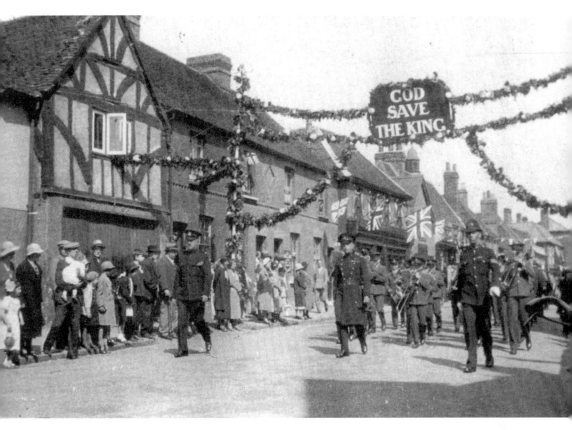

Shopkeepers in Burnham decorated the High Street for every festive or royal occasion. Here, in 1937, the police lead a procession of all the local organizations to celebrate the coronation of George VI.

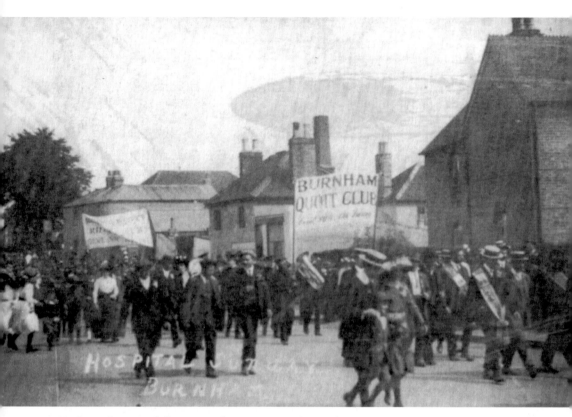

In the early part of the twentieth century one day each year was set aside as Hospital Sunday. Parades took place to encourage the public to make donations to help maintain the local hospitals. Here in 1912 the Quoit Club (above, which met at The Alma pub) is marching in Gore Road, while the man in the bath chair (opposite, top) depicting the 'grateful patients' aspect is in the High Street. A later parade (opposite, bottom) includes the old Velvet ice-cream cart, a product of the Ice Company on the trading estate.

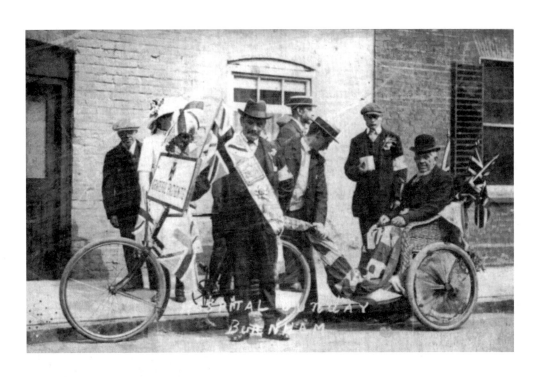

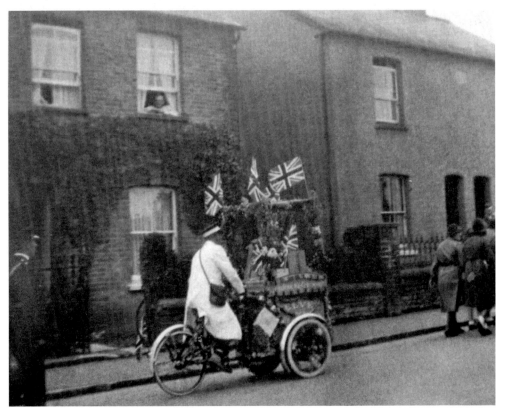

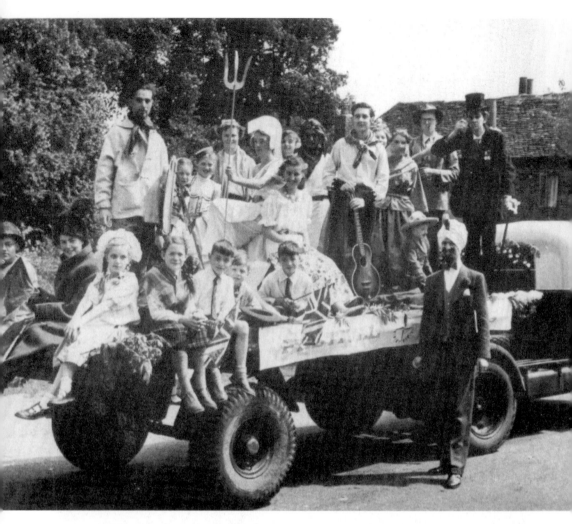

A group depicting the Festival of Britain, 1951. These young people are part of a parade to raise money to renovate the church bells. Among them are D. Turner, E. Summers, V. Pearce, A. Thorpe, R. Freathy, D. Russell-Smith, J. Willmott with her twin brothers, J. Hamilton, T. Cordwell, H. Saffery, P. Robins, J. Enticknap, D. Severn, ? Robins and W. Summers.

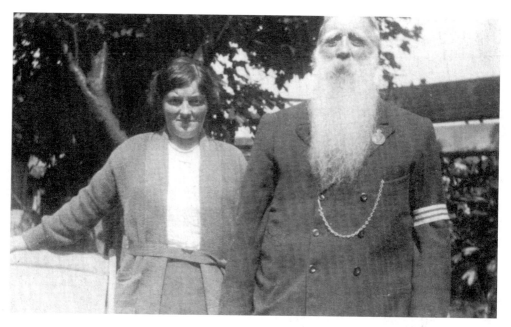

Old Robert Lawley in his late seventies, wearing his special constable's, uniform, during the First World War. With him is one of his two daughters who ran Lawley's newsagents for many years. Robert was a well-known character and was instrumental in producing the Burnham Minstrel Troupe (below left), with his son Henry, in the early 1900s. Robert lived to be ninety-five. Other entertainments were provided by the Burnham Musical Society (below right).

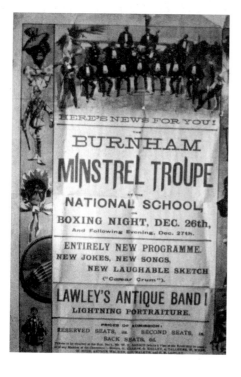

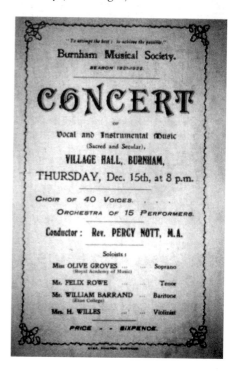

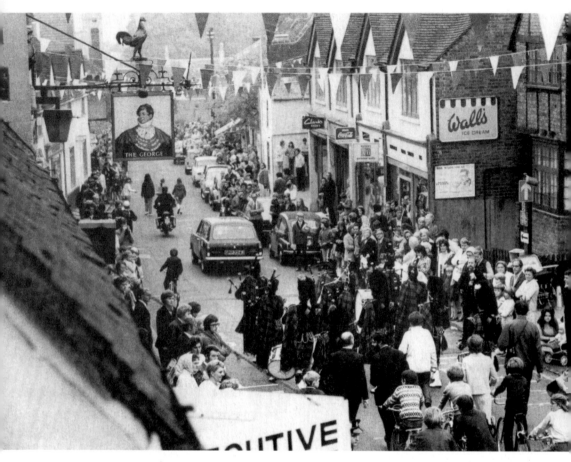

An unusual view of the southern part of Burnham High Street, 1970s. Spectators look surprised to see a Scottish pipe and drum band among them. The band is in the carnival parade, which began Burnham Week. It was later to entertain the public in the arena in Burnham Park.

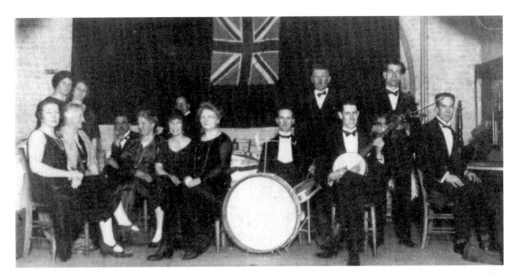

Burnham Dance Band on the stage of the old village hall in Gore Road, 1930s. The pianist was Tommy Eason from The Garibaldi, and the dance was held to celebrate a royal occasion.

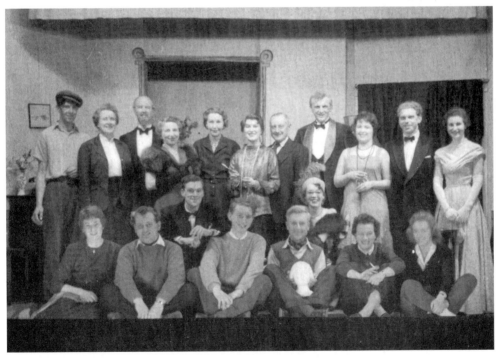

The Burnham Dramatic Society's cast of *Who is Sylvia?*, 1958. Standing, left to right: P. Millership, F. Freathy, B. Bradford, K. Thorpe, P. Nash, M. Haddon, J. Freathy, G. Thomas, L. Green, N. Stanley, A. Thorpe. Seated: J. Colquhoun, D. Bester, R. Freathy, T. Bradford, G. Pepler, V. Pearce, T. Bradford, J. Bradford.

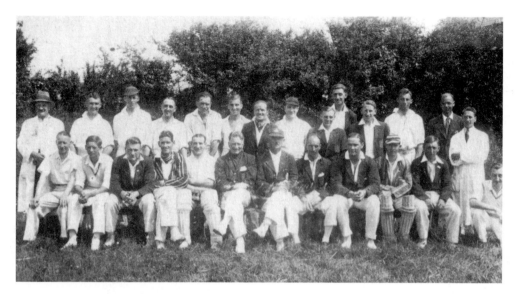

Burnham Cricket Club, 1930s. Standing, left to right: -?-, P. Bennett, M. Pierce, F. Farr, -?-, -?-, -?-, A. Ratcliffe, -?-, -?-, R. Sands, S. Williams, -?-, A. Sands. Seated: -?-, -?-, E. Bennett, -?-, -?-, Captain W. Piggott, -?-, G. Williams, -?-, W. Isherwood, H. Cory, -?-.

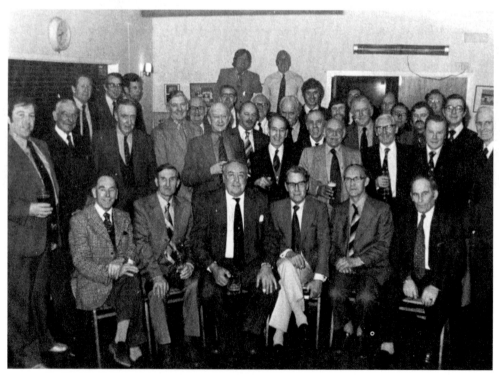

In the club house, Burnham Cricket Club members are celebrating their 150th anniversary, 1978. Included are E Lees, R. Evans, A. McKinnon, A. Sands, .J. Hastie, E. Lake, G. Moon and G. Hearn.

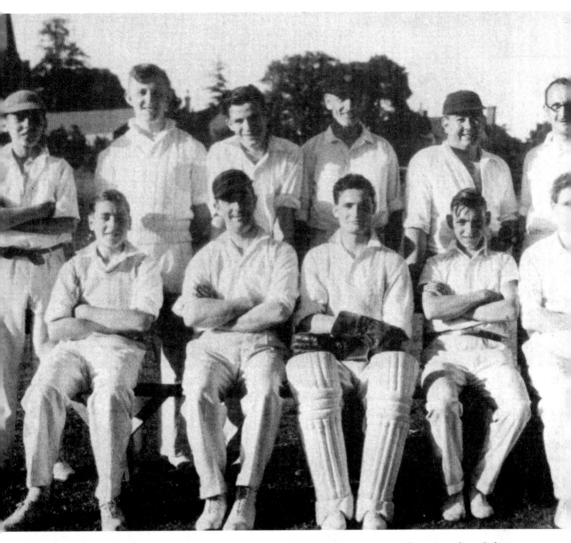

Burnham 3rd XI in around 1939 at the new playing-fields, now St Peter's Close. Standing, left to right: J. Cory, P. Thatcher, -?-, -?-, -?-, -?-, -?-. Seated: E. Lake, -?-, -?-, ? Bond, -?-. (Further names would be welcomed.)

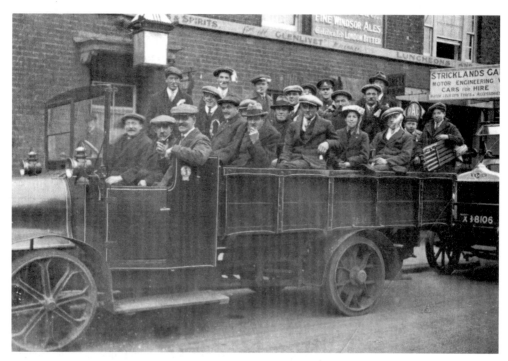

Burnham Football Club supporters in around 1920, setting off to watch their team in an away game. Gordon Strickland, who owned The George Hotel and Strickland's Garage, was a member of the team.

The village turned out to celebrate their football team's victory when it won the Bucks and East Berks Junior League, 1920/21.

The Athletics Sports Day, 1922. This took place on the Gore Sports Field, the use of which was given to the village in 1920 by Edward Clifton-Brown.

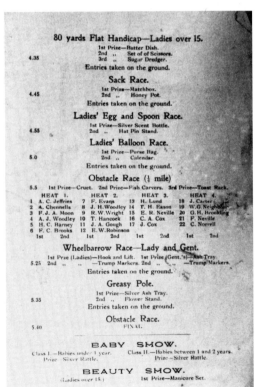

Events on the programme for Athletics Sports Day, 1922. The prizes were donated by local dignitaries.

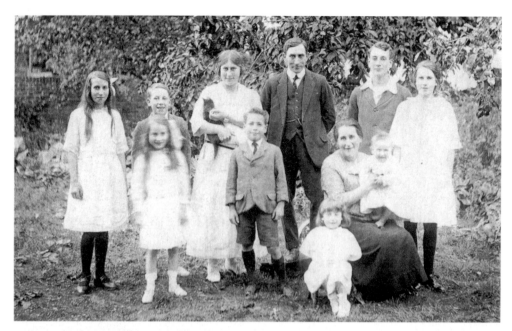

William Sands with his wife, Grace, and nine of their ten children, 1924. Left to right: Molly, Robert, Jean, Gwen, Alfred, William, Margaret, Grace, Richard, baby Patrick and Dorothy.

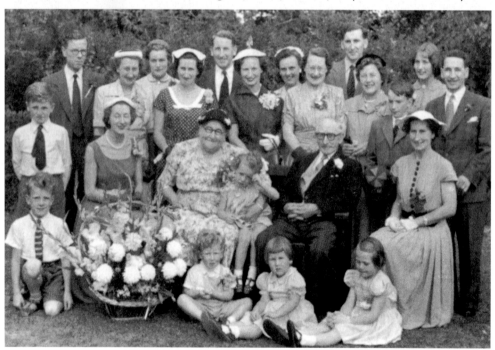

William and Grace Sands' Golden Wedding Day, 1955. Through the family garage, and their involvement with the United Reformed Church and with guiding, football, cricket, etc, the Sands family have made a considerable contribution to Burnham village life.

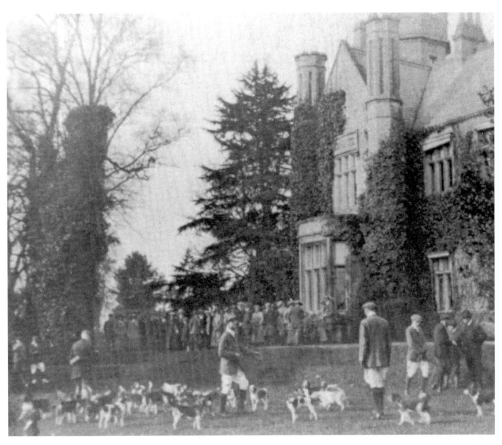

At the turn of the century using beagles to hunt hares was a popular sport. Here outside The Priory, owned by Captain Farwell, the pack owners are preparing for a day's hunting.

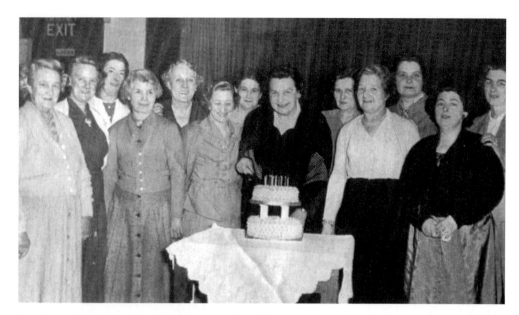

Burnham Afternoon Townswomen's Guild celebrating their twenty-third anniversary in the village hall, 1956. Left to right: Mrs Davis, Mrs Critchley, Mrs Chivers, Mrs Brister, Mrs Arnold, Mrs Way, Mrs Brown, Mrs Gamble, Mrs Cooper, Mrs Swift, Mrs Cook, Mrs Bovington, Mrs Wisbey.

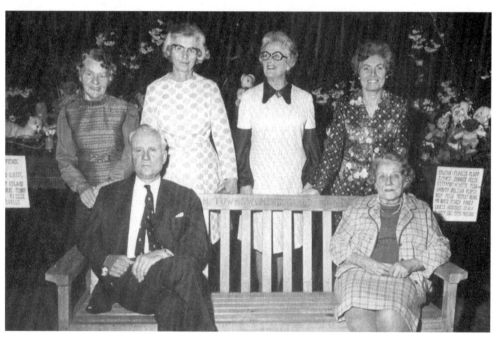

The Afternoon Townswomen's Guild presenting George Pepler with a bench for the use of villagers, 1973. The presentation, made by (left to right) G. Aria, W. Wisbey, F. Freathy, C. Stanley and B. Arnold, was to mark the fortieth year of the guild.

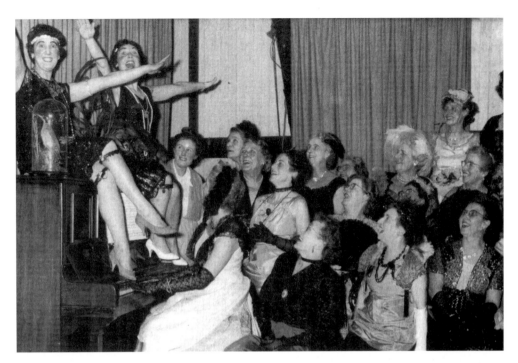

The Townswomen's Guild Choir presenting a revue, 1956. At the piano is P. Melville Richard. J. Partington and C. Stanley are on the piano. Others include I. Martin, W. Wisbey, K. Cook, P. Hughes, B. Arnold, E. Bryson, D. Tegg, A. Jackson, R. Streather, D. Budgen and R. Barnicoat.

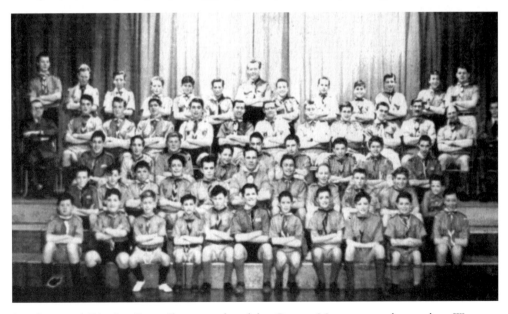

Burnham and District Gang Show, produced by George Montague and staged at Westgate School, 1960. Among the scout leaders are A. Neighbour, S. Gowing, P. Bodnell, A. Grout, J. Hirons, J. Soper, M. Puttock, L. Cutler and G. Montague.

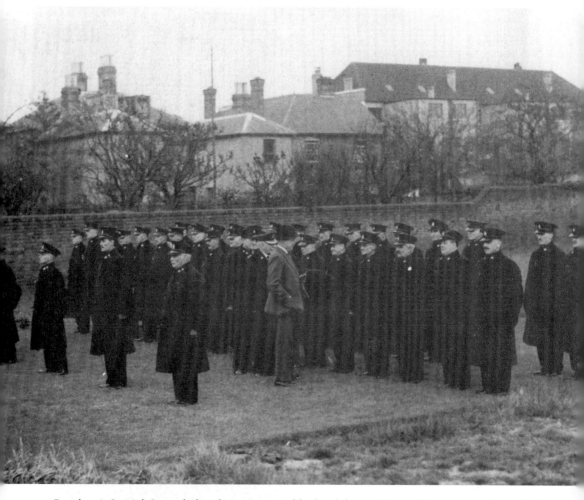

Burnham's Special Constabulary being inspected by local doctor Maxwell Summers in the walled garden of The Priory, 1938. In the front row are Thomas Doran (ex-headmaster) and Henry Lawley.

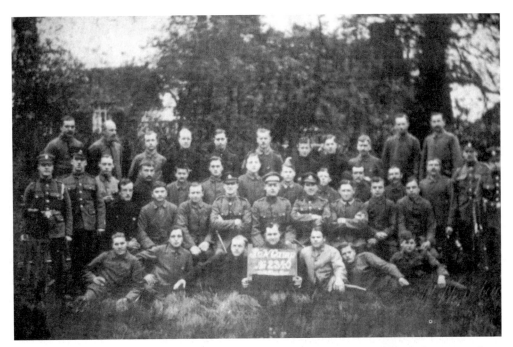

German prisoners of war in Burnham, 1915. The camp was in the house called Sunnycroft, at the junction of Britwell Road and Green Lane. Those on either side wearing hats are the English guards. The prisoners were used as agricultural labourers locally.

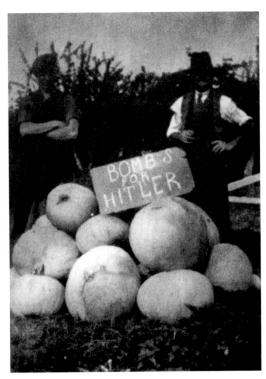

When the public were encouraged to 'dig for victory' in 1940, these two enthusiasts took it literally.

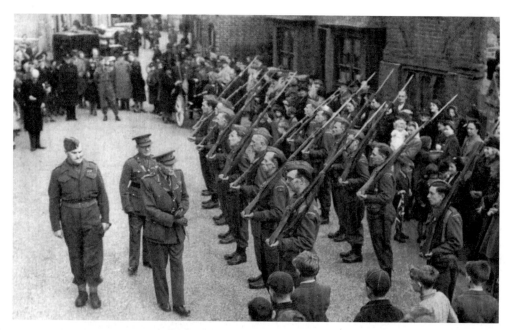

The Home Guard on parade, Church Street, 1944. In the front row are Tom Taylor, George Draper and Bob Sands. At the far end of the second row are Jack Thorpe and Bill Chivers. A visiting high-ranking officer is inspecting them. The Home Guard was disbanded in December 1944.

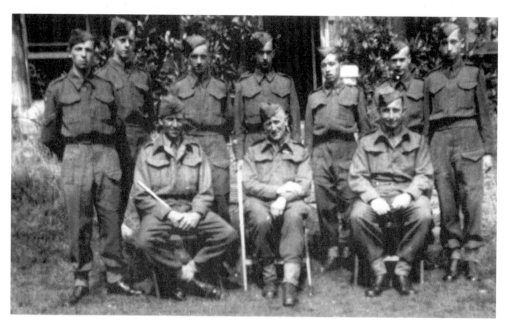

'B' Company 1st Bucks Cadet Battalion, 1944. Standing, left to right: Corporal D. Blackman, -?-, -?-, -?-, G. Cleaver, Corporal G. Tizzard, -?-. Seated: Lieutenant F. Cleare, Captain D. Jones, Lieutenant S. Wilkins.

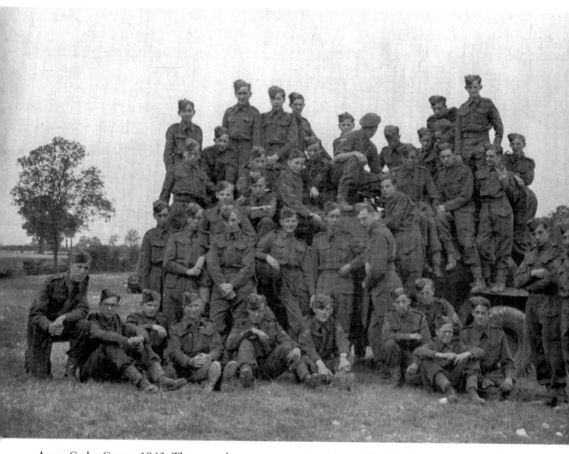

Army Cadet Camp, 1943. The annual camp was a serious part of training to prepare young men for war. Among this group are Ron Laye, George Cleaver, Charlie Brewerton, Don Blackman, Ron Trimming and Alf Bishop, all from Burnham Village.

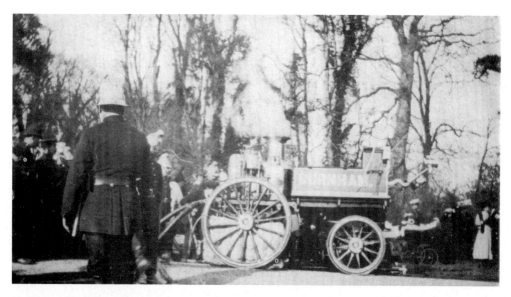

Burnham's first steam fire engine, a Merryweather Greenwich 'Gem', one of only three in Britain. It was paid for by donations and is seen here pumping water from the village pond, *c.* 1910.

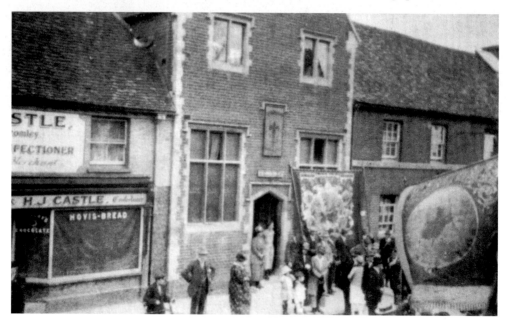

A gathering outside the Mission Hall next to The George, where a hospital parade is underway, *c.* 1912. The Boy Scout banner hangs over the doorway as the Mission Hall was the headquarters of the troop.

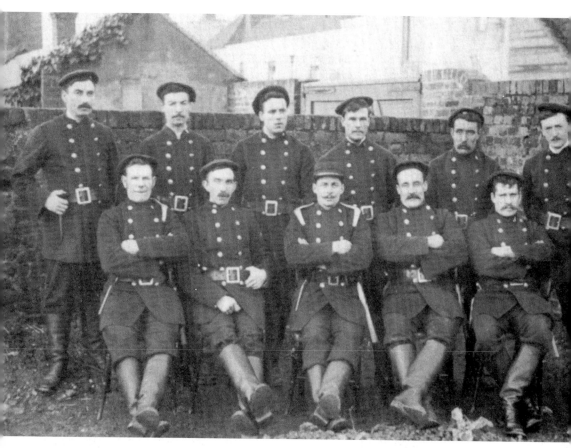

The fire brigade opposite the Crispin, *c.* 1910. Back row, left to right: H. Lawley, J. Painter, -?-, -?-, ? laycock, A. Hyde. Seated: -?-, -?-, -?-, A. laycock, -?-.

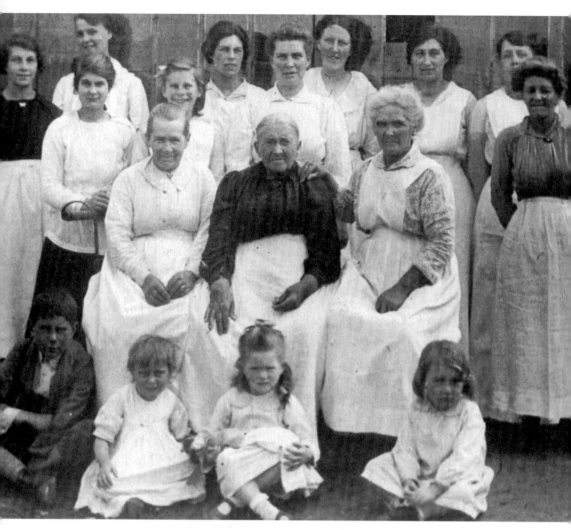

Bradley's laundry ladies, 1918. Standing, left to right: D. Isaac, M. Bradley, D. Pusey, R. Bradley, P. Hughes, O. Bradley, I. Bradley, C. Bradley, E. Hall, A. Pusey. Seated: Mrs Harris, Mrs Simmonds, Mrs Pusey. Children: Eddie Bradley, Joyce Bradley, Natalie Hall, Vera Wilson. The laundry was at Cardigan House in Gore Road, where Minniecroft Road is now. Just across the road was their friendly rival, Harris's, later Dawes' laundry, which continued until it became Lipscombe's.

Opposite, top left: The ladies of Dawes' laundry, 1930s. Left to right: L. Poole, L. Knight, Mrs Dawes, H. Appleton, N. Quarterman, ? Hoborough, F. Appleton, S. Adaway. Top right: Propping up the washing line are F. Gunn and L. Poole. Bottom: Advertisement for Bradley's laundry.

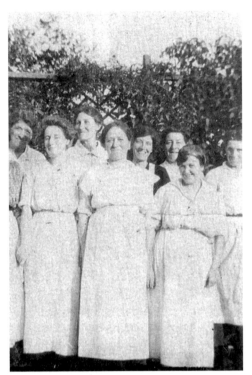
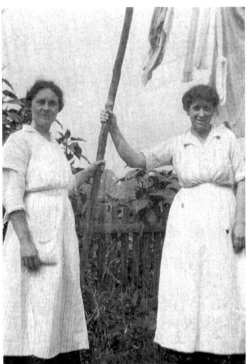

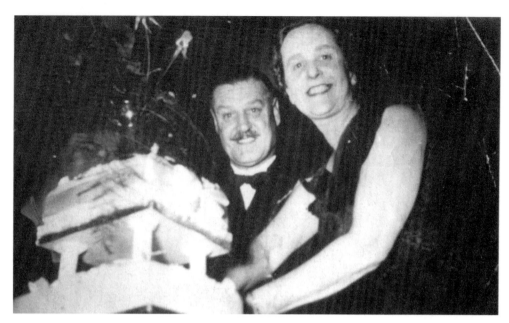

Dr Maxwell Summers and his wife Dr Evelyn Summers. They are cutting a cake at a surprise silver wedding party given by parishioners in the village hall. They were a very popular couple who served the community in many ways. Both lived to be over ninety.

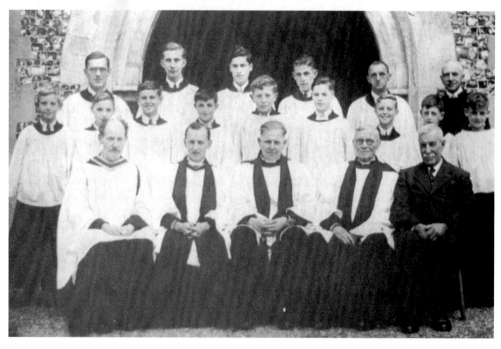

St Peter's church choir, 1940. Standing, left to right: -?-, C. Griffiths, D. Freeman, E. Chant, R. Millership, A. Maybank, A. Parrot, -?-, A. Watts, -?-, A. Derrick, B. Derrick, A. Hulm, H. Hulm, B. Hulm. Seated: H. Rhodes, -?-, Revd Hugh Read, -?-, F. Cleare.

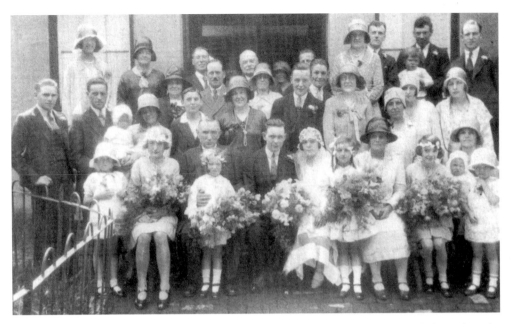

A wedding at the Congregational church, Gore Road, 1930s. The bridegroom belonged to the Totman family, who lived in North End where Alma Court now stands.

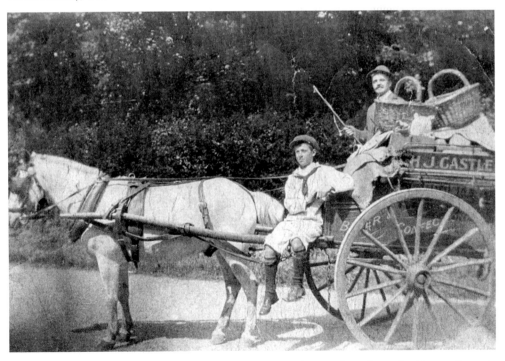

Fresh bread was brought to the door daily in the 1920s. The cart, here driven by George Gunn, is piled high with loaves and covered to protect it from rain. Castle's Bakery was in Burnham High Street on the corner of Dawes East Lane.

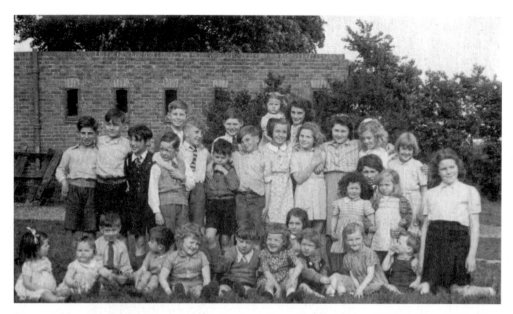

These children have something to smile about at the end of the Second World War, 1945. They are about to have a party, and among them are R. Manhood, P. Thatcher, ? Hulm, M. Jaycock and G. Murkett.

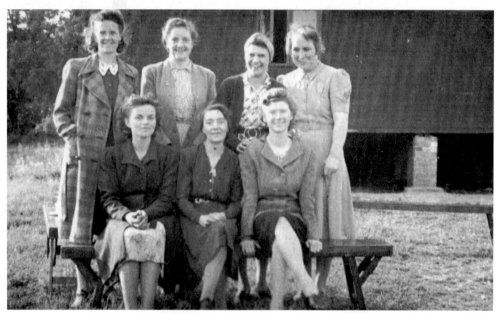

The ladies who provided the party (see above), at the Youth Club Hut behind the infants school, where St Peter's Close is. Standing, left to right: Mrs Woodward, F. Murkett, Mrs E. Jaycock, Mrs Light. Seated: Mrs Hulm, Mrs Manhood, Mrs Vinton.

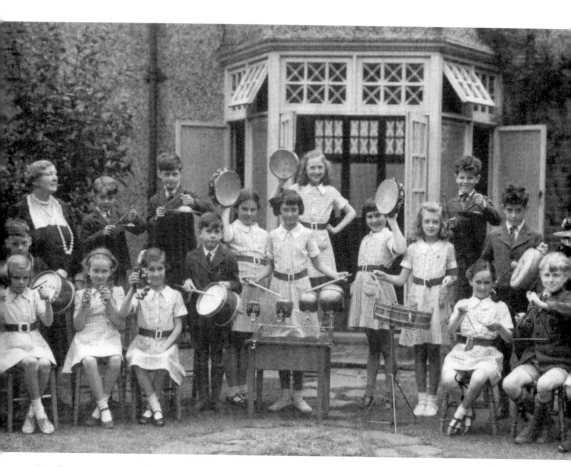

Reedham House School Band, 1942. The school stood in Britwell Road. When it moved, part of the building became the Penstone Veterinary Clinic. It has now been demolished to make way for a service road for shop deliveries. Standing, left to right: Roger Freathy, Mrs Fuller, Malcolm Vigo, Keith Bunce, Barrie Thorpe, -?-, -?-, -?-, Fuchsia Williams, Judy Bacon, Bruce Bartlett, Roger Bartlett, Geoffrey Jaques, Colin Ward. Seated: Greta Garcke, Joanna Fleming, Coral Larkin, Ann ?, John Enticknap, Rosemary Ferguson.

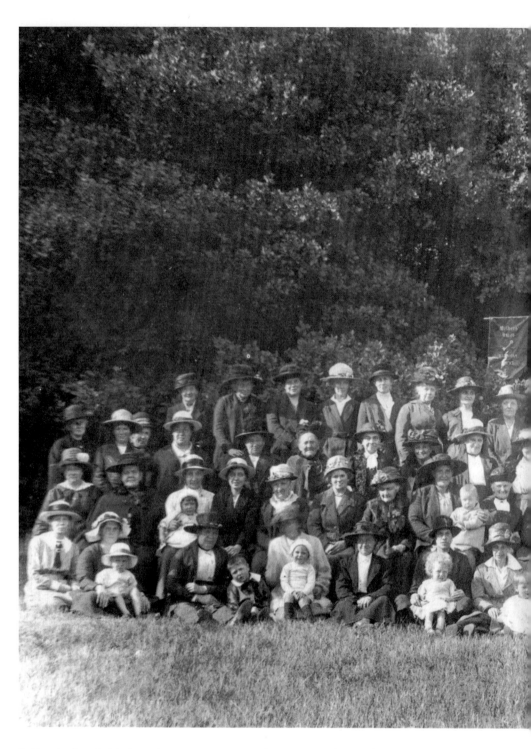

St Peter's church Mothers' Union, *c.* 1924. In the centre is the Revd Percy Nott. Behind him to the right is Mrs Caudell, holding her son Billy. Also present are Mrs Carter, Mrs Evans,

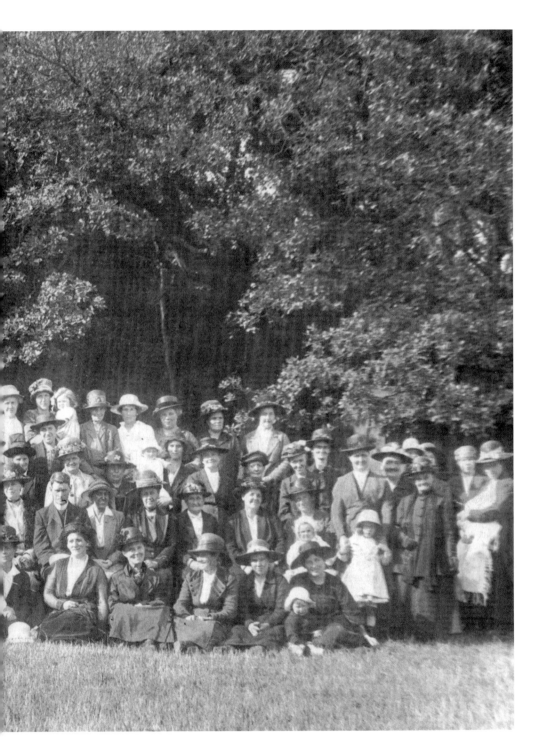

Mrs Simmonds and Mrs Blackman.

ACKNOWLEDGEMENTS

This book has been made possible by many local people volunteering to lend their precious old photographs. Our thanks are owed to the following friends and organizations:

Mrs K. Alexander • Dr G. Barney • Mr M. Bayley • Miss D. Bennett
Mr D. Blackman • Mr M. Boxall • The *Bucks and Berks Observer* Burnham
Afternoon Townswomen's Guild • Mrs P. Dugan • Mrs J. Eastgate • Mr P. Felix of
Shire Publications • Mrs R. Ferguson • Mr J. Gates • Mr E. Goodrham
Mr R. Grant • Mr G. Gunn • Mrs E. Hall • Mrs J. Handley • Mrs P. Hartigan
Mrs C. Heming • Mrs G. Hill • Mr W. Horwood • Mrs E. Jaycock • Mr A. Keen
Mr E. Kennedy • Mrs M. Keylock • Mrs N. Kirton • Mrs R. Lawley
Mr R. Lechmere • Mr G. Lines • Mrs E. Lund • Mrs K. McKeown • Mr R. Manhood
Mr R. Millership • Mrs B. Montague • Mrs M. Noyce • Mrs F. Packe
Mrs A. Pilsbury • Mr M. Rice • Mr A. Sable • Mr A. Sands • Mr H. Slader
The *Slough and Windsor Express* • Mrs J. Stebbings • Miss D. Strafford
Mr B. Thorpe • Mr M. Twist, author of *The Spacious Days* (Farming Press)
Wexham Park Hospital Department of Medical Illustration • Mrs C. Whelan
Mrs A. Wrighton

Our very special thanks are owed to Mary Bentley, a fellow member of Burnham Historians, for all the typing involved in this book and for her valued comments.

We have made every effort to establish copyright and have obtained permission to reproduce material where appropriate. If we have failed to do this in any case we offer our apologies.